CW00540761

William Morris.

CHARLOTTE & PETER FIELL

WILLIAM MORRIS

1834–1896

A Life of Art

TASCHEN

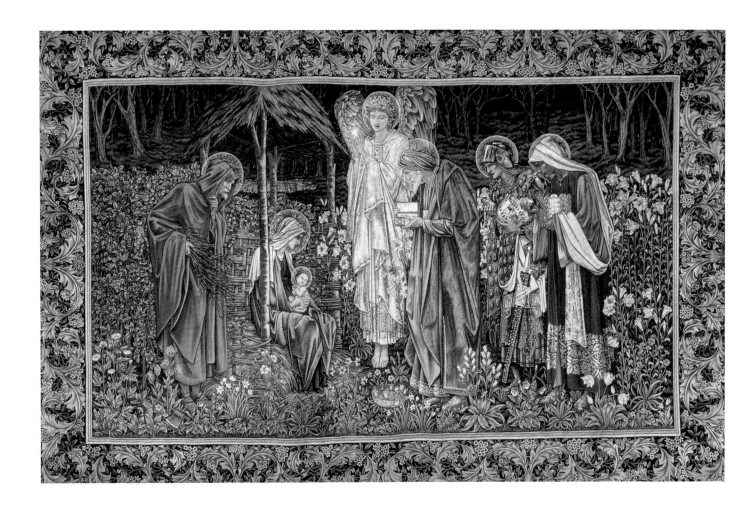

**EACH AND EVERY TASCHEN BOOK
PLANTS A SEED!**
TASCHEN is a carbon neutral publisher. Each
year, we offset our annual carbon emissions
with carbon credits at the Instituto Terra,
a reforestation program in Minas Gerais, Brazil,
founded by Lélia and Sebastião Salgado. To find
out more about this ecological partnership,
please check: *www.taschen.com/zerocarbon*
Inspiration: unlimited. Carbon footprint: zero.

To stay informed about TASCHEN and our
upcoming titles, please subscribe to our free
magazine at *www.taschen.com/magazine*,
follow us on Instagram and Facebook, or e-mail
your questions to *contact@taschen.com*.

© 2020 TASCHEN GmbH
Hohenzollernring 53, D–50672 Köln
www.taschen.com

Printed in Slovakia
ISBN 978–3–8365–6163–1

Page 2 ▶ William Morris, *c.* 1884

Above ▶ Edward Burne-Jones,
The Adoration of the Magi tapestry, 1906

Contents

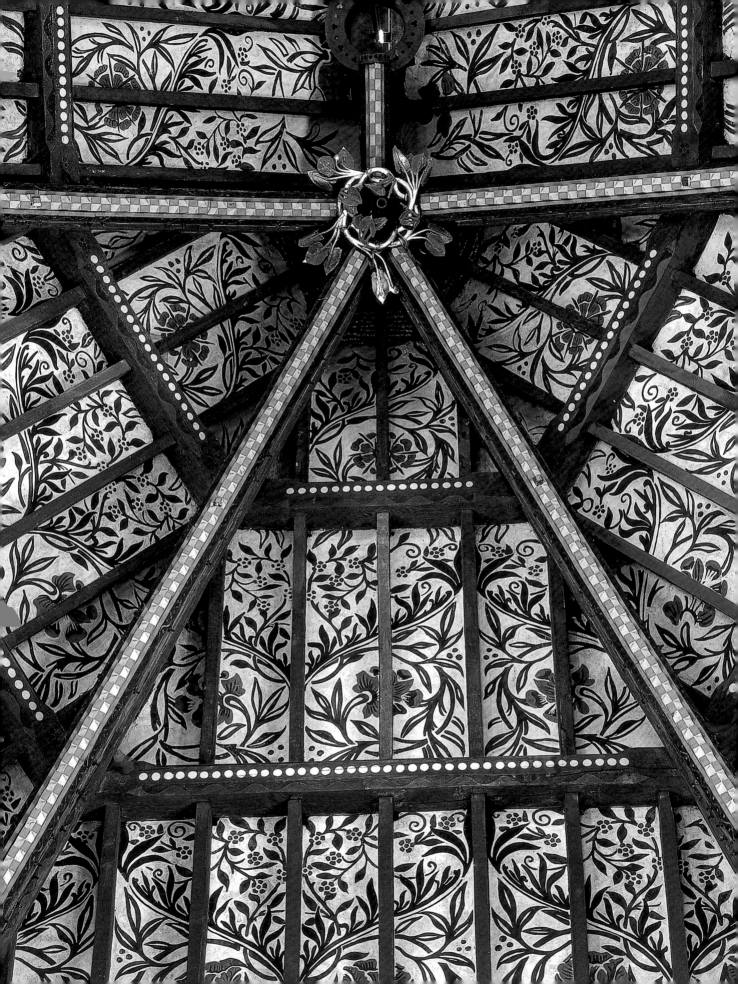

Introduction

William Morris was a revolutionary whose life and work were shaped by a dream of a medieval Arcadia and, ultimately, a vision of a fraternal Utopia. These illusory worlds, that looked to the past and to the future, provided him with a means of escape from the age in which he lived as well as the inspiration to change it. Driven by his "hatred of modern civilization",[1] Morris sought to reform both art and society by demonstrating through practice a better and more ethical way of doing things.

In his own lifetime, Morris was most highly noted for his poetry and prose. Today, however, he is primarily remembered for the many designs he executed that were manufactured and retailed by Morris & Co., a co-operative firm he established in 1861. But more than this, he was a visionary political activist who, through educating, agitating and organizing the Socialists in his crusade for "Liberty, Equality and Fraternity", helped lay the foundations of the British Labour Movement.

Morris's activities must be seen within the context of the spirit of reform that permeated the latter half of the 19th century in a reaction to the unprecedented transformation taking place in the structure of Victorian society. The success of Britain's manufacturing industries and the exploitation of its extensive Empire had brought a prosperity which fuelled both the rise of the professional middle classes and the urbanization of the working classes. Although appearing superficially stable, at its core Victorian society was thus now deeply divided by class and economic inequality. Industrialization had polluted cities and destroyed social cohesion through the displacement of workers, while the division of labour turned skilled workers into an unskilled workforce that was becoming increasingly disconnected, not only from the object of its labours, but also from society in general.

The frantic commercial competition underpinning Britain's free market economy led many manufacturers to produce even more fanciful luxuries and gimmicks in order to rival their competitors. To this end, superfluous ornament was increasingly used to disguise the poor quality manufacture of products, while workers became enslaved to the machines that produced them. Early design reformers such as Augustus Pugin (1812–1852), John Ruskin (1819–1900) and Owen Jones (1809–1874) recognized that the prevailing High Victorian style was the result of a society corrupted by greed, decadence and oppression and strove to change the status quo through a reform in art.

The repressive, conservative and often hypocritical values of the Victorian Age also gave rise to an artistic and idealistic rebellion in the mid-1840s, led by the painters

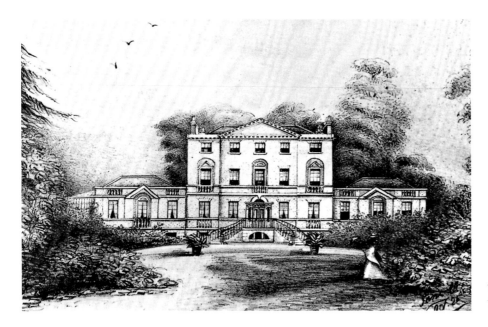

Dante Gabriel Rossetti (1828–1882), William Holman Hunt (1827–1910) and John Everett Millais (1829–1896). The romantic escapism popularized by this group, known as the Pre-Raphaelite Brotherhood, later inspired a larger movement of artists, designers, writers and poets, which included among its members William Morris. Central to this movement was the dream of a medieval Arcadia – a highly romanticized notion of pre-industrialized society that offered a refuge from the conditions of the time.

This intangible "vision of a past already lost and reconstructed by the past",[2] which looked upon community as a socially cohesive force and creative handiwork as the fountainhead of fellowship, wholly informed Morris's life and work. He was also guided by the reforming theories of John Ruskin and, for his part, endeavoured to return dignity to labour through his activities at Morris & Co. Attempting to balance social conscience with business objectives by producing well-designed and executed objects that were handcrafted, this means of reform was compromised by the economic conflict that exists between handcraftsmanship and affordability. This dichotomy, together with Morris's distrust of mechanization for social reasons, meant that his ideal of a truly democratic or "popular" art was as unattainable as the dream that had inspired it.

The fundamental paradox between Morris's dreamworlds and the reality of the Victorian Age was only one of many that existed within his life and work: the rich man who preached revolution to the poor; the gentleman and the artisan; the bard and the businessman; the "idle singer of an empty day" driven "to do the work of ten men"; and the hopeless romantic caught in a loveless marriage. The inherent contradictions surrounding Morris, however, do not lessen the validity of the essential and underlying meaning of his work. Indeed, these paradoxes make it all the more engaging because in most cases it can be seen to embody both a dream of the past and a vision of the future, while remaining a powerful testament to its own time.

A Privileged Childhood

William Morris was born on 24 March 1834 at Elm House in Clay Hill, Walthamstow. He was the third of nine surviving children and the eldest son of William and Emma Morris. William Morris Snr was a successful discount-broker working at Sandersons in

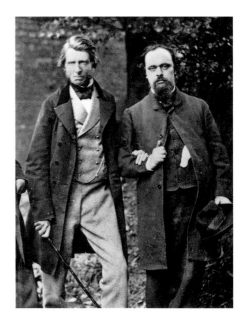

The Oxford & Cambridge Magazine,
published by Bell & Daldy, no. VI, June 1856

the City of London. A remarkably shrewd businessman, he also had a ruggedness, as his son, who inherited these qualities, was to note in the 1860s: "I am a boor, and a son of a boor".[3]

In 1840, having become prosperous, the Morris family moved to Woodford Hall, a substantial Georgian mansion with a 50-acre park bordering Epping Forest. Their social status was now on the ascent, with the Herald's College granting the family a coat-of-arms in 1843. It was this essentially nouveau-riche background, described by Morris as "the ordinary bourgeois style of comfort",[4] that he was so fervently to rebel against.

The Morris family's financial fortunes continued to rise when William Morris Snr helped to form a consortium to mine the land of the 7th Duke of Bedford. In 1845 the enterprise was registered as The Devonshire Great Consolidated Copper Mining Company (also known as Devon Great Consols). From the outset, the Morris family held some 30 per cent of the company's stock. The venture was to become one of the most lucrative mining interests of the period and the family profited handsomely from it.

The extraordinary profits allowed Morris, according to Walter Crane, the "fortunate circumstance that he was never cramped by poverty in the development of his aims".[5] It was perhaps his sense of guilt about how his family's wealth had been obtained – through human exploitation and the despoilment of nature – that in time drove Morris's ceaseless attempts to right social wrongs. The horrific nature of working conditions in mines had become common knowledge as a result of a report drawn up by a commission on the insistence of Lord Shaftesbury, which cited shocking revelations. This damning account of the Victorian mining industry enabled the heavily resisted Mines Act of 1842 to be passed, but it was not until 1860 that the employment of children under the age of ten was outlawed in mines.

Sheltered from the harsh realities of the poor, the young William Morris became an avid reader and by the age of seven had reputedly read the complete works of Walter Scott, who was to remain Morris's favourite author, for he recreated a past with a "rose-tinted" realism that was both atmospheric and seemingly authentic. His imagination was transfixed by medieval history, especially the chivalry of knights.

From an early age, Morris was blessed with keen powers of observation and an almost photographic memory – attributes that were essential to his later work as a designer. As a child he was given his own patch of garden to cultivate, which spawned an interest in botany. Meanwhile, long childhood rambles instilled in him a deep pantheistic love of and respect for the natural world.

During one of his childhood wanderings in Epping Forest, Morris's sense of history was sharpened by his chance discovery of Queen Elizabeth I's almost forgotten Hunting Lodge at Chingford Hatch. To Morris, this building was an embodiment of "Ye Olde Englande", and it was the mythology surrounding this romantic notion of English history that he was to pursue in different forms throughout his life. Another building that left an impression on Morris was Canterbury Cathedral, and later in life he came to regard such sublime architectural beauty as the expression of an ideal society.

Morris was initially taught by a governess at home, before being sent at the age of nine to the Misses Arundel's academy for young gentlemen as a boarder. A few months before Morris went to public school, however, his father died suddenly at the age of 50. This untimely death may well have been brought on by worries about the imminent collapse of Sandersons, which had to suspend business a week later. With no income from Sandersons and the loss of partnership capital, the mining shares of Devon Great

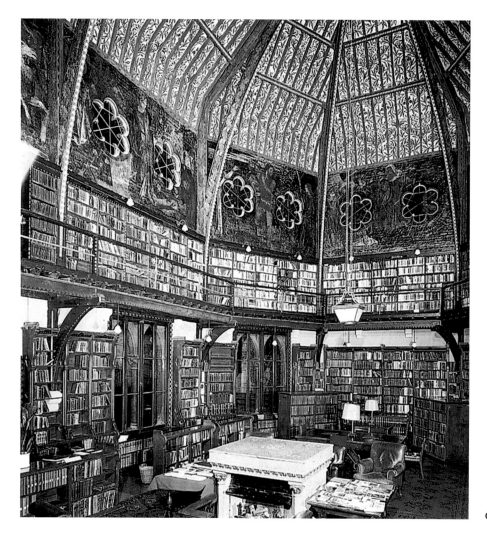

Consols were a lifeline to the Morris family, which subsequently moved to a smaller and less expensive home, Water House in Walthamstow.

Before his death, Morris's father had purchased a nomination for his son to attend Marlborough College. This newly founded public school in Wiltshire was utterly chaotic, as the number of boys attending was continually swelling and buildings were having to be rapidly constructed to accommodate them. Less expensive than other public schools, Marlborough was also less strict than similar teaching establishments, although it likewise used a stultifying rote learning system of teaching.

In this environment, the homesick William Morris immersed himself in the school's library, well stocked with books on archaeology and ecclesiastical architecture. With his great powers of imagination, Morris became a favoured storyteller in the dormitories at night, although his peers best remembered him for his famous outbursts of temper.

He would later profess to have learned nothing apart from rebellion at "Boy Farm" (Marlborough) and said of his time there: "One naturally defies authority".[6] Whether he was involved in the alarming riot that occurred at the school in 1851 is not known, but shortly afterwards, he was removed from the school and placed under the tutelage of the Revd Frederick Guy, later to become Canon of St Alban's.

Revd Guy taught Morris theology, Latin and Greek, and as a High Church Anglican sympathetic to the Anglo-Catholic Movement, his formative influence on Morris was

significant. Guy, being a member of the Oxford Society for Promoting the Study of Gothic Architecture, undoubtedly grounded Morris in the arguments of the Gothic Revivalists, who considered the Classical style pagan, yet believed the Early Gothic style to be Christian and at one with nature. Unlike 18th-century "Gothick", which was mainly a secular style and influenced by Perpendicular Gothic, the "Reformed Gothic" style of the 19th century was predominantly ecclesiastical in nature.

Oxford and the Reformers

By now Morris intended to read theology at Oxford before entering the Church, and in 1852 he took his entrance exam for Exeter College, Oxford. During the examination he sat next to Edward Burne-Jones, who also aspired to take Holy Orders and who was to become his closest friend when Morris finally started university the following year.

Morris described Oxford as "a vision of grey-roofed houses and a long winding street, and the sound of many bells".[7] At the centre of university life during the first half of the 19th century was the Oxford Movement, which sought a renewal of Roman Catholic theology within the Church of England. Its members, known as Tractarians, sought the increased use of ceremony and ritual within the Anglican service and

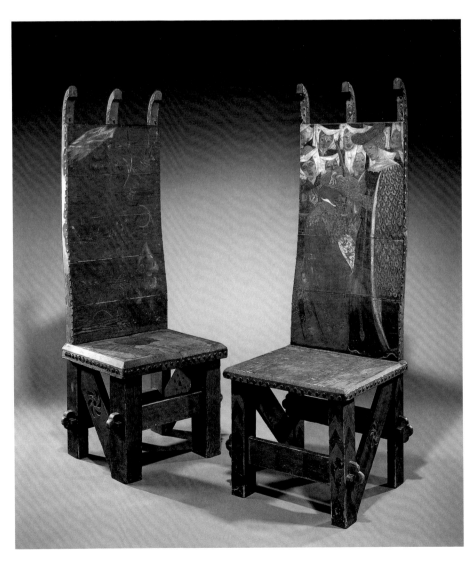

William Morris (design), Edward Burne-Jones & Dante Gabriel Rossetti (decoration), Pair of high-backed chairs, 1856

established Anglican monastic communities. By the time Morris arrived, Oxford had become the country's main missionary centre and a stage for fierce debates that raged within the Church of England between the Anglo-Catholics and its liberal wing.

Receptive to this heady climate of controversy and reform, Morris was nevertheless disappointed with his choice of college. Exeter was divided into two distinct groups: serious scholars and a rich, fast set, known as "Hearties", that pursued entertainment with mindless abandon. Although the latter were his social equals, Morris did not really fit in with either camp and preferred the company of fellow aesthetes such as Edward Burne-Jones, who came from a modest family. Together with Burne-Jones, Morris found intellectual stimulation through a group of friends known as "The Set", which included Pembroke College men William Fulford and Richard Watson Dixon, as well as Charles Faulkner and Cormell Price. The Set constantly teased Morris and nicknamed him "Topsy" because of his unruly mass of curly hair. Within the group, Morris happily played the role of buffoon, although occasionally his humour would forsake him and be replaced with fits of temper.

Disillusioned by the dullness of formal studies at Oxford, Morris found solace in the study of medieval history. Falling under the influence of High Church Anglicanism, he and Burne-Jones toyed with the idea of converting to Catholicism. This brief affair with the Church of Rome, however, was quickly remedied by the progressive theories of John Ruskin and the Christian Socialist Charles Kingsley, who as a supporter of Charles Darwin sought to reconcile modern science with Christian doctrine. The ideas of democracy and social welfare found in the writings of Ruskin and Kingsley were the seeds from which Morris's own social doctrine would grow.

While at Oxford, Morris was also roused by Thomas Carlyle's book, *Past and Present* (1843), which attacked industrial capitalism by contrasting it unfavourably with the daily life of a 12th-century monastery. Studies into the Middle Ages such as this revealed the attraction of a pre-capitalist society made up of organic and socially cohesive communities. Carlyle looked to "Feudal Socialism", a term coined by Karl Marx and Friedrich Engels, as a means of social salvation. As with Ruskin and Kingsley, Carlyle's concepts of society and morality shaped Morris's view of the world. However, during these early years, his appetite for direct involvement in the "muddle" of politics was overshadowed by his love of art and poetry.

Edward Burne-Jones later recollected of Morris: "From the first I knew how different he was from all the men I had ever met. He talked with vehemence, and sometimes with violence. I never knew him languid or tired. He was a slight figure in those days; his hair was dark brown and very thick, his nose straight, his eyes hazel-coloured, his mouth exceedingly delicate and beautiful."[8] During their first term together at Oxford, Morris and Burne-Jones submerged themselves not only in Anglo-Catholic tracts but also in Alfred Tennyson's "The Lady of Shallot", a poem inspired by Sir Thomas Malory's tale, *Le Morte d'Arthur,* written around 1470. The Victorian fascination with the Arthurian legend had been ignited by Sir Walter Scott's rediscovery of Malory's text in the late 18th century. With its quasi-Christian morality based on the chivalric deeds and brother-hood of King Arthur and his Knights of the Round Table, the myth captured both the hearts and minds of the two young romantics and offered them an intellectual refuge from the reality of England's increasing industrial bleakness.

It was probably Burne-Jones who initially came up with the idea of making their "escape" real by founding a quasi-religious community involving vows of celibacy and

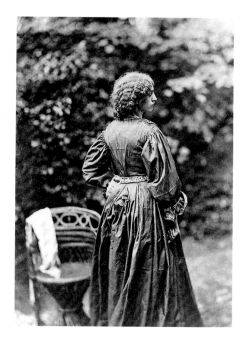

Jane Morris posed by Dante Gabriel Rossetti in his Cheyne Walk garden, July 1865
Photograph by John Parsons

monastic austerity. While this notion of an Arthurian-like brotherhood, which would embark on a "Crusade and Holy warfare against the age",[9] was clearly inspired by Malory, it was also prompted by the Pre-Raphaelite Brotherhood set up by William Holman Hunt, John Millais and Dante Gabriel Rossetti in 1848. The PRB was itself influenced by the earlier German Nazarene painters who established the semi-theological Lukasbrüder community in Vienna in 1809. Similarly founded as a reformist movement in art, the PRB at the same time acted as a medium for the Romantic spirit of the mid-19th century, at the heart of which was a love of a dream-like medieval Golden Age.

The short-lived Pre-Raphaelite journal, *The Germ*, was especially influential upon Morris and his friends, who, in its wake, founded *The Oxford and Cambridge Magazine*.

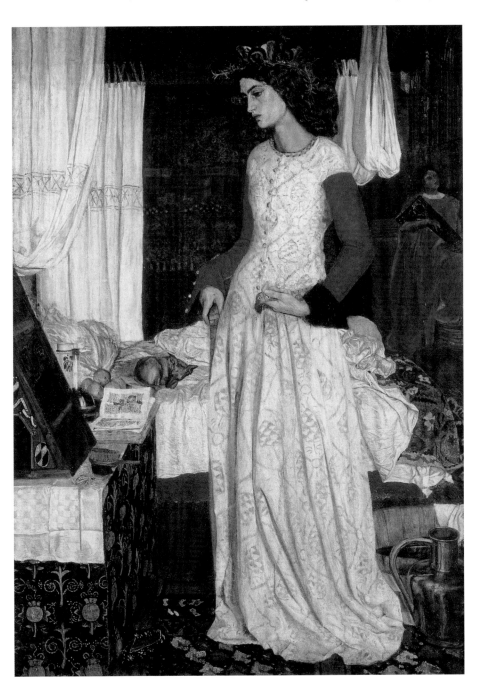

William Morris, *La Belle Iseult*, 1858–59

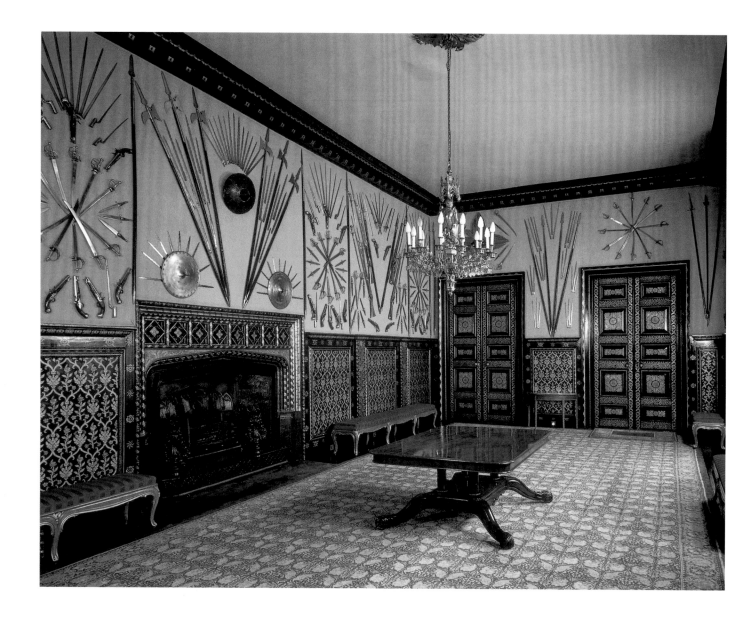

This periodical was heavily subsidized by Morris, who contributed prose stories, poems, poetry criticism, art and architecture criticism to 10 of the 12 issues.

The Armoury, St James's Palace, 1866–67

The most important influence on Morris during this time, however, was John Ruskin, and specifically his second volume of *The Stones of Venice*, which Morris regarded as revelational. Ruskin was one of the first to explore the social damage caused by materialism and to highlight the disconnection of creativity and labour within the industrial system. As a social reformer, Ruskin understood the dignity of manual creativity and the interconnection of art and society. Above all he desired a society made up of "gentle-men". Unlike Carlyle, who believed all labour to be noble, Ruskin maintained only creative work would benefit society as a whole. For Ruskin, the division of labour was the primary cause of social alienation, and he believed that the precision of machine-made objects signified the increasing estrangement of the worker – who was neither creatively nor intellectually engaged – from his work. Morris later acknowledged Ruskin as his ideological mentor and put many of his theories into practice.

At Exeter College, Morris began to write evocative and extremely pantheistic poetry. These poems or "Grinds", as they were referred to by The Set, came to him naturally, and he said of them: "Well, if this is poetry, it is very easy to write".[10]

During his final summer vacation of 1855, Morris made his second trip to France, this time with Burne-Jones and Fulford. It was to be a walking tour and a journey of discovery with the friends visiting a total of nine cathedrals and 24 churches. Morris regarded architecture as the supreme discipline, because it provided a unique focus for all the arts. For him, the undeniable perfection of Chartres Cathedral, connected holistically to its surrounding townscape, validated the social system that gave rise to it – medieval feudalism or "commune-ism". It was this idea of a whole community pulling together creatively – making, building, doing – that appealed to Morris above all else.

One evening, while strolling alongside the quay at Le Havre towards the end of their tour, Morris and Burne-Jones made the momentous decision to embark on "a life of art"[11] instead of taking Holy Orders as they had originally planned. It was decided that Burne-Jones would become a painter and that Morris would pursue a career as an architect.

"A Life of Art"

Shortly after his return from France, Morris informed his mother that he was to abandon theology in favour of architecture. Morris, nevertheless, did return to Oxford on his mother's insistence to take his theology degree in the autumn of 1855. The following January, he became articled to the architect George Edmund Street in Oxford. As a leading Gothic Revivalist, Street was mainly involved in the design and restoration of ecclesiastical buildings. Favouring the robust vernacular style of Early Gothic, Street's architectural approach verged on the organic, which had a significant influence on Morris.

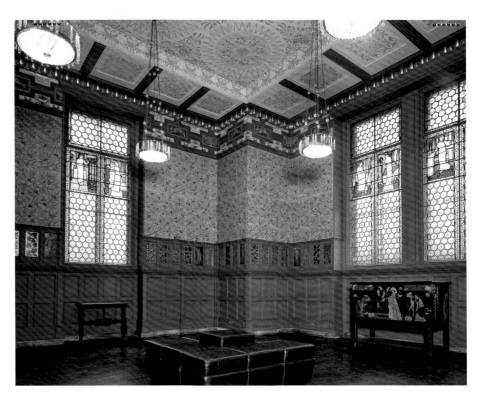

The Green Dining Room,
South Kensington Museum, 1866–67

Street's most notable pupils were Philip Webb, John Sedding and Norman Shaw, and upon entering the office Morris was placed under the supervision of Webb, who was three years his senior and was to become a long-standing friend and colleague. Ironically, in later life Morris decried Street's work and became the most vehement critic of his former master's "restorations".

While at Street's office, Morris continued to write poetry in the evenings. In June 1856, the office moved to London, where Burne-Jones was now also living. At Ruskin's instigation, Burne-Jones had finally met his hero, Dante Gabriel Rossetti. Although only five years older than Burne-Jones, Rossetti was far more worldly. He was already a notable figure in artistic circles, having co-founded the Pre-Raphaelite Brotherhood.

Rossetti was also highly charismatic, and from their very first meeting Morris fell under his Svengali-like influence. By July 1856, upon the urgings of Rossetti, Morris abandoned his short-lived architectural career and decided to become a painter. He wrote to a friend: "Rossetti says I ought to paint, he says I shall be able to; now as he is a very great man and speaks with authority and not as the scribes, I must try".[12]

For a while Morris and Burne-Jones shared rooms at 1 Upper Gordon Square, and there Burne-Jones became engaged to Georgiana MacDonald. At the suggestion of Rossetti, in late November 1856 the two friends moved into three large unfurnished rooms at 17 Red Lion Square. Morris immediately busied himself with the decoration of their new accommodation, and finding only shoddy furniture available, set about designing his own. The resulting medieval-inspired chair designs were painted with scenes from Morris's poem, "Sir Galahad, A Christmas Mystery".

In the summer of 1857, Rossetti gathered a group of like-minded artists, including Morris and Burne-Jones, and set off to paint murals of scenes from Malory's *Le Morte d'Arthur* on the walls of the Oxford Union Library. While Morris thoroughly enjoyed the bonhomie, the project itself was ill-founded as correct preparation procedures were disregarded and the unfinished murals began to fade within six months. Rossetti, who from 1852 had been unofficially betrothed to the consumptive Lizzie Siddal, scoured Oxford for "stunners" who could sit as models for the murals. One such girl was an 18-year-old raven-haired ostler's daughter, Jane Burden, whom he met at a theatre. She subsequently agreed to sit for him as Queen Guinevere, and over the following sessions Jane succumbed to Rossetti's spell and he to her unconventional beauty. In November, however, Rossetti had to leave Oxford suddenly to rejoin the long-suffering Siddal, and Jane began to model for Morris's painting of *La Belle Iseult* – ironically, the unfaithful wife of the King of Cornwall in Malory. Falling hopelessly in love, he reputedly inscribed the back of the canvas, "I cannot paint you but I love you",[13] acknowledging his infatuation with her and his struggle with the medium.

The besotted Morris wrote several poems inspired by Jane's beauty and these, together with other non-moralizing verses, were eventually published in March 1858 at Morris's own expense as *The Defence of Guenevere*. This was the first anthology of Pre-Raphaelite poetry to be published and it was met with general derision due to its rough eroticism and earthy archaic style. Although Jane was in love with Rossetti and later maintained she had never loved Morris, she nonetheless became engaged to him in the summer of 1858. Coming from a humble background, it is unlikely Jane was in much of a position to do anything else, and between her engagement and marriage to Morris was probably coached in the skills needed for her forthcoming ascent in the class system. Rossetti and the Morris family were notable by their absence at

W. A. S. Benson, Table lamp retailed by Morris & Co., *c.* 1890

Philip Webb, Pair of candlesticks, 1861–63

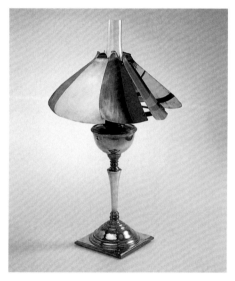

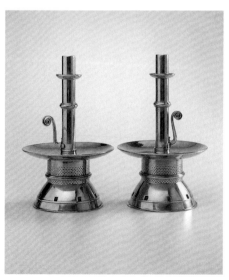

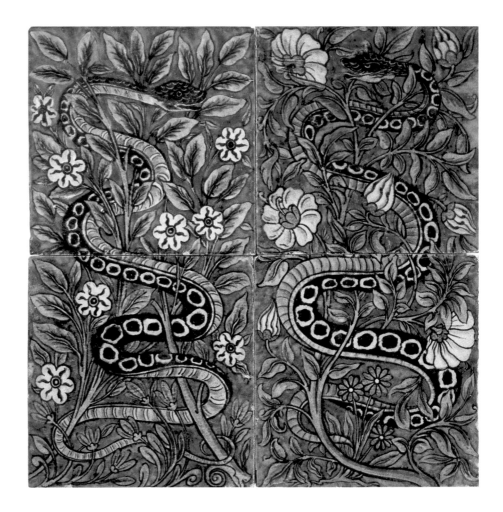

William De Morgan,
Four-tile panel, 1890s

William and Jane's wedding, which took place at St Michael's Church, Oxford on 26 April 1859.

On their return from a six-week honeymoon the Morrises lived in Great Ormond Street while their marital home was being built in Bexleyheath. The Red House, dubbed the "Towers of Topsy" by Rossetti, was designed by Philip Webb in close collaboration with Morris. Upon completion it was furnished by Morris and his circle of friends with embroidered hangings, murals, stained glass and heavy painted furniture (such as "The Prioress's Tale" wardrobe, a wedding gift from Burne-Jones) inspired by the 13th-century Gothic style. The fellowship of this collaborative interior-decorating project led to the formation of Morris, Marshall, Faulkner & Co. The Red House was a veritable palace of art and a reification of Morris's dreams of a medieval Arcadia.

In January 1861, Jane Alice (Jenny) was born, the first of two Morris children. A few months later Rossetti and Siddal, who had married in 1860, were devastated by the birth of a stillborn daughter. Lizzie, who for years had had to cope with Rossetti's numerous infidelities, including his blatant affair with Fanny Cornforth, one of his models, now became addicted to the opiate sleeping draught, laudanum. A few months before the Morrises' second child, Mary (May), was born, Lizzie took an overdose of laudanum and died. Rossetti, racked with guilt at her death, turned to Jane for consolation, and so began an infamous liaison.

Morris, Marshall, Faulkner & Co.

In 1861 Morris, who had never had any gainful employment nor income from *The Defence of Guenevere*, now resolved to find a career for himself – mainly because his dividends from Devon Great Consols shares were beginning to falter. Despite abandoning the church, architecture and painting, Morris had nonetheless developed a connoisseur's eye for quality and a natural empathy for materials, texture, colour and pattern. These attributes were vital to the success of his future enterprise. As a result of his experience with the decoration of the Red House, Morris decided, probably at the instigation of Ford Madox Brown, to form an association of artists to produce better designed and executed objects. The establishment of Morris, Marshall, Faulkner & Co. was no doubt influenced by Henry Cole's earlier Summerley's Art Manufactures venture, although the two enterprises differed significantly. Whereas Cole sought to reform mainstream design through the Establishment, Morris – inspired by the theories of Ruskin – attempted a revolutionary approach that tackled the social aspects of design head-on and which involved, for the most part, a rejection of the industrial process.

Initially, only two of the seven partners of The Firm received a salary, Morris and Faulkner, while the other key partners, Brown, Rossetti, Burne-Jones and Webb, were paid piecemeal for their design work. In April 1861, The Firm issued its first prospectus, announcing: "These Artists having been for many years deeply attached to the study of the Decorative Arts of all time and countries, have felt more than most people the want of some place, where one could either obtain or get produced work of a genuine and beautiful character. They have therefore now established themselves as a firm." It was declared that the company would undertake the design and production of mural decoration, carving, stained glass, metalwork and furniture. Burne-Jones already had experience in the design of stained-glass windows and it was in this area that The Firm achieved its earliest success.

Louis Haghe, *The Great Exhibition: the Medieval Court*, 1851

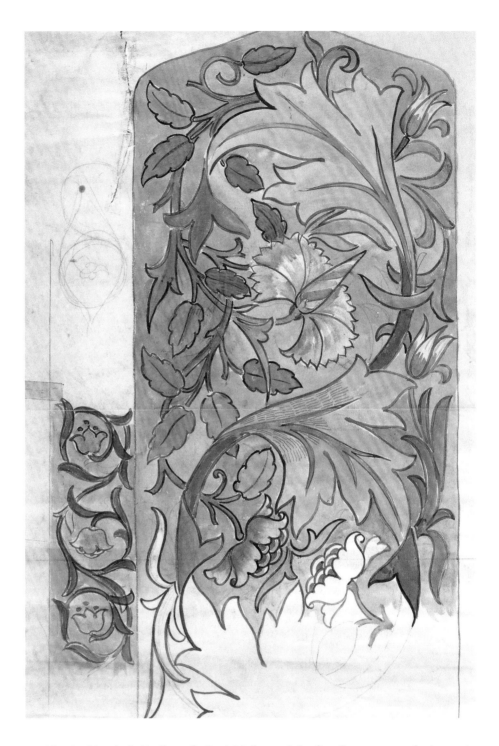

Morris, Marshall, Faulkner & Co. initially used the first-floor rooms of a house in Red Lion Square as showrooms and offices, and set up a furnace in the basement for the firing of stained glass and tiles. The Firm also subcontracted work to a nearby cabinetmaker, Mr. Curwen, and to the glass manufacturer James Powell & Sons. The partners' wives and sisters were drawn into The Firm, while other independent designers such as William De Morgan and W. A. S. Benson supplied designs to it. Destitute boys from London's East End were also employed and trained to work in the workshops.

By turning his attentions primarily to the practice of handwork and commercial endeavour, Morris – an educated member of the upper middle classes – repudiated the

Victorian social convention that separated "gentlemen" from the working classes by becoming, in essence, a trading artisan. Given his background and social rank, this was considered a rather disreputable thing to do. Nevertheless, The Firm began to receive commissions, many of them ecclesiastical; fortuitously, the 1860s marked a highpoint in Victorian church building and restoration. Morris, Marshall, Faulkner & Co. exhibited its work, including the *King René's Honeymoon* cabinet designed by John Pollard Seddon and decorated by Morris, Burne-Jones, Rossetti and Ford Madox Brown, in the Medieval Court at the 1862 International Exhibition at South Kensington, to both acclaim and ridicule. The Firm was awarded two gold medals, not for its design innovation, but for how faithfully it had reproduced the crafts of the Middle Ages.

Morris, Marshall, Faulkner & Co. owed its success to Morris's ability to control and co-ordinate The Firm's creative output, and he threw himself wholeheartedly into numerous projects. As artistic director, Morris forged a recognizable "look" which promoted the virtues of simplicity, utility, beauty, symbolism and quality. The many designs produced by The Firm exemplified the attributes which Morris advocated through his well-known dictum – that one should "have nothing in your house that you do not know to be useful or believe to be beautiful".[14] Throughout his prolific career, Morris created over 600 designs for wallpapers and textiles as well as over 150 designs for stained glass.

In late 1864 Morris was recovering from a bout of rheumatic fever and was becoming tired of his daily commute from Bexleyheath to Red Lion Square. His visions of an artistic community centred at Red House, in which the Burne-Jones family would live in a proposed extension, were dashed by the latter's decision to remain in London due to a lack of funds, ill health and the loss of an infant through scarlet fever. Morris also had financial worries brought on by the poor financial performance of Morris, Marshall, Faulkner & Co., and the dwindling income received from Great Devon Consols stock. Eventually, he decided to move his family back to London. During this time, his marital relations with Jane worsened considerably, and it is probable she demanded the move back to the city which led to the sale of his beloved Red House the following year. With the increasing financial pressures and the dawning realization that his marriage would remain loveless because his wife loved another, Morris immersed himself in his work and entered into a period of intense activity.

Queen Square

In the autumn of 1865, the Morris family moved into a large house at 26 Queen Square. This Bloomsbury address also provided Morris, Marshall, Faulkner & Co. with the larger premises it now required. Like the Red House, Queen Square functioned as a showhouse and complementing the decorative scheme, Jane, the languorous mistress of the house, wore flowing unrestricting medieval-style costume. Effectively "living over the shop", Morris found he was becoming increasingly involved in the day-to-day running of The Firm. Of his fellow partners, too, Marshall had resumed his career as a surveyor and sanitary engineer, Faulkner had returned to Oxford and Rossetti was dedicating the majority of his time to painting. Despite the many orders it had received from the beginning, by 1865 The Firm was in trouble. This all came down to Morris, for although he was a highly competent design manager, he was not as financially astute as he could have been. This was due largely to Morris's personal expenditure and his over-generosity to his partners.

The second drawing room at 1 Holland Park, London, 1893

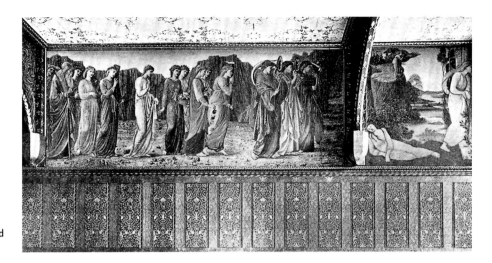

The Earl of Carlisle's residence, at 1 Palace Gate, London, designed by Philip Webb and decorated by William Morris, incorporating the Cupid and Psyche frieze painted by Edward Burne-Jones

Realising that The Firm would fail unless it could be brought under financial control, Morris appointed George Warington Taylor as its business manager. Taylor, who suffered from consumption, held this position until his premature death in 1870 and was solely responsible for The Firm's dramatic financial turnaround. In 1869 Taylor decreed that Morris had to end his lavish entertaining and reduce his wine consumption to two-and-a-half bottles a day or he would bankrupt The Firm.

By introducing a more business-like ethos into The Firm and by curtailing Morris's spending, Taylor transformed the co-operative of artists into a well-run and increasingly profitable organization. Its range of designs became more market-orientated, with The Firm now producing somewhat plainer, English vernacular-inspired items such as the Sussex and Rossetti chairs, which were less costly than the earlier, highly decorated medieval-style furnishings. These new designs articulated a simpler, more democratic and accessible style that was to have much influence on later generations of designers.

In 1866, The Firm secured two important public commissions: the redecoration of the Armoury and Tapestry Room at St James's Palace and the interior design of the Green Dining Room at the South Kensington Museum. These projects brought official recognition to The Firm as well as much-needed profits. The Firm also undertook many private interior design projects for clients such as the artists Birket Foster and Val Prinsep. With Taylor as business manager, Morris was now able to devote more time to poetry and this offered an escape from his difficult marital arrangements.

The Earthly Paradise

Morris began composing his most famous written work, *The Earthly Paradise*, in 1865. The form of this narrative poem cycle was inspired both by Chaucer's *Canterbury Tales* and Boccaccio's *Decameron*. This 40,000 line epic poem, which Morris referred to as "The Big Story Book", included 23 stories from Greek mythology and Norse legends and one of Arabic origin. Burne-Jones designed over 500 woodcut illustrations for it. Of these, Morris cut over 50 himself and in so doing, mastered the art of block cutting. When it was first published, however, only one woodcut was used as a frontispiece.

For Morris, poetry was not a special vocation but just another craft to be mastered. Unlike *The Defence of Guenevere*, the first volume of *The Earthly Paradise*, which was published in 1868, received much critical acclaim and sold extremely well. Its title predicts Morris's later political struggle against "the ugliness of life lived penuriously and

repressively"[15] and his yearning for a modern and humane Utopia. For a decade after its publication, Morris was the most popular poet in England.

Paradoxically, although Morris was one of the most celebrated Romantic poets of his time, he acknowledged his own emotional retentiveness and blamed it on his Englishness. Nevertheless, he had deeply held libertarian views, and it was in this light that he attempted to ignore his wife's infidelities. While Morris was always more at ease in the company of men, he did become a close confidant of Georgiana Burne-Jones when her husband fell in love with the Greek sculptress Mary Zambaco. It is likely that Morris and Georgiana had a brief affair and certainly they remained emotionally, if not physically, tied for many years. Morris was later to become an advocate of free love.

While living at Queen Square, Jane's relationship with Rossetti deepened, and with Morris's complicity she frequently sat unchaperoned for him at his house in Cheyne Walk. A series of professionally taken photographs of Jane posed by Rossetti in his garden have distinct erotic undertones and bear witness to their intimacy. By now, Jane and Rossetti's affair was common knowledge in certain London circles. Revealingly, Rossetti's poetry from this period regales the joys of love, while Morris's *The Earthly Paradise* laments autobiographically over the loss of love and the pain of unrequited love.

Bad Ems and Marital Problems

In 1869, Jane and Morris spent six weeks at the German spa town of Bad Ems so that she could take a cure for what was in all likelihood a gynaecological ailment. The copious correspondence between Jane and Rossetti must have been vexing for Morris: many of the letters from Rossetti were illustrated with darkly satirical cartoons that were sarcastic references to the Morrises' marriage. While the Morrises were at Bad Ems, Rossetti became deeply melancholic and began to display suicidal tendencies.

Shortly after his return from Bad Ems, Morris turned his attention to the art of calligraphy, and between 1870 and around 1875 planned and to varying degrees executed some 21 manuscript books. Of these, only two were completed, while the other unfinished projects were represented by trial pages and manuscript fragments. Morris was also busy with his translations of Icelandic sagas during this same period, and it is not surprising that many of his manuscript books borrowed texts from these works. Inspired by medieval, Carolingian and Renaissance manuscripts, Morris used a quill rather than a steel nib and developed five scripts for the books. Through his efforts, Morris revived and renewed the painstaking art of calligraphy and his manuscript books should be considered intensely personal expressions of his creativity. One such work, *A Book of Verse*, was given to Georgiana Burne-Jones as a birthday present, and with its remarkably rich detailing, was truly a labour of love. But by now, Morris had another intimate female confidante, Aglaia Coronio, the daughter of his friend and client, Alexander Ionides.

In spring 1871, Morris began searching for a country residence for the ostensible reason that his daughters' health would benefit from the change of air. It is likely, however, that Morris realized his wife's affair with Rossetti needed to be conducted away from the scrutiny of London circles if scandal were to be avoided. Morris and Rossetti subsequently signed a joint lease on Kelmscott Manor, a beautiful yet unpretentious Elizabethan manor house in the Oxfordshire Cotswolds that became his rural ideal.

Rossetti moved into Kelmscott Manor prior to Jane and her daughters' arrival in June and commandeered the Tapestry Room for a studio. As soon as his family was

Jane Morris posed by Dante Gabriel Rossetti in his Cheyne Walk garden, July 1865
Photograph by John Parsons

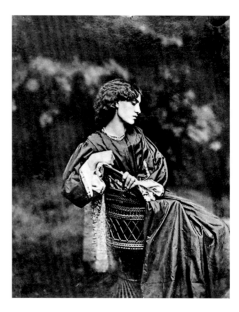

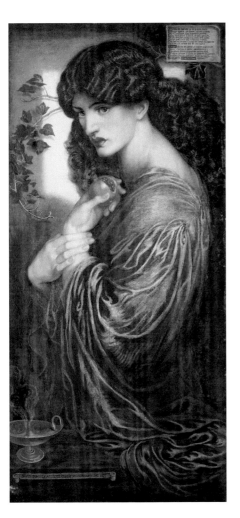

Dante Gabriel Rossetti, *Proserpine*, 1874
Between 1871 and 1877, Rossetti painted Jane Morris as Proserpine, the Queen of Hades, a total of eight times. Rossetti may well have seen Jane as queen of his own personal hell and his addiction to her as a force driving him to self-destruction

installed, Morris left for Iceland, although prior to his departure he wrote to his wife entreating her to find happiness. By taking out the joint tenancy of Kelmscott with Rossetti, Morris provided a more stable environment for Rossetti's affair with Jane, and in so doing, clearly demonstrated his acquiescence to it.

The Icelandic Saga

Morris made two trips to Iceland, in the summer of 1871 and the other in 1873. These journeys to a land untouched by industrialization were to have a great effect on Morris's political thinking. Although he encountered the "grinding poverty" of its people, he felt these poor citizens were better off than their "wage-slave" contemporaries in Britain, because they did not exist in a society torn apart by a class system. For him, Iceland's early and primitive democracy was a protomedieval manifestation of a socialist system and therefore worthy of deep admiration.

Travelling with three companions on his first six-week visit, Morris was able to escape the insidious influence of Rossetti. His fellow travellers were his colleague Charles Faulkner, Mr W. H. Evans of Forde Abbey in Dorset (a recent acquaintance) and the Icelandic linguist Eiríkr Magnússon. From their first meeting in 1869, Magnússon had taught Icelandic to Morris and assisted him with his translations of the sagas.

Experiencing nature at its most extreme, Morris and his friends set off on a pilgrimage to the landmarks described in the sagas he knew and loved so well. The near-monastic simplicity of life in Iceland powerfully reinforced Morris's belief in the inherent morality of dematerialism in design and the social importance of crafts. Indeed, this Icelandic odyssey marked a turning point in his life – having been pushed to his physical and mental limits, he now returned to England spiritually rejuvenated.

The Rural Ideal

On his return home, Morris delighted in his new country residence, Kelmscott Manor, a modestly sized Elizabethan manor house that he described as "heaven on earth". Morris came to view the Cotswolds as the mystic centre of England's beautiful verdant countryside. The small and remote hamlet of Kelmscott itself corresponded entirely with his ideal of a self-sufficient rural community and inspired his later Utopian novel, *News from Nowhere*. Importantly, Morris's promotion of communities such as these influenced later social reformers and led to the building of garden cities.

In the spring of 1872, Morris went down to Kelmscott with the plan that Jane and their children would follow in the summer. When the time came, however, they were delayed in London because Rossetti had suffered a complete nervous breakdown. By early June, Rossetti descended into increasing paranoia and began hearing voices and ringing bells. By the end of September he nevertheless returned to Kelmscott and remained there until 1874, when even Jane had to accept the seriousness of his mental condition. The pressures on Morris at the time were immense. During this period Morris published "Love is Enough", a poem which reflected his own complex relationships with Rossetti, Jane and Georgiana.

In 1872 the Morris family and The Firm moved to Horrington House in Turnham Green, to allow for more showroom space and a small dye house at Queen Square. A year later Morris designed his first chintzes, which were produced by Thomas Clarkson. Unhappy, however, with the fastness of the dyes used, Morris began exploring the techniques of textile dyeing and made frequent visits to Leek in Staffordshire,

then a major centre for the silk industry. Here he was introduced to the art of dyeing by Thomas Wardle. With his arms plunged into enormous vats of indigo and wearing a workman's blouse and sabots, Morris was filled with joy as he undertook this "delight-ful work, hard for the body and easy for the mind".[16]

The trips to Leek also brought Morris to a better understanding of the effects of industrialization. Although he did not disagree with the workers' long hours, he found the mind-numbing repetition of the production line repugnant. It was the compart-mentalization of the industrial process that was of most concern to him, because he believed that through the division of labour the worker's well-being and the arts as a whole were harmed. But Morris was not opposed to mechanization if it could be used to produce items of quality, and indeed some Morris & Co. carpets were machine woven. He did, however, object to modern aniline dyes, which were unstable and often garish in tone, and insisted on the use of age-old vegetable dye recipes, which provided subtler tones.

During this period, Jane spent most of her time at Kelmscott with the increasingly erratic Rossetti. By the spring of 1874, however, Morris could no longer bear his pres-ence there and threatened to relinquish his own share of the lease on the Manor unless Rossetti moved out. Over this turbulent period, the Morris family holidayed in Bruges with the Burne-Joneses. While they were away, Rossetti had an ugly contretemps with a group of anglers whom he believed were persecuting him and so, requiring no more persuading, was hastily removed from Kelmscott by his hangers-on.

Now Rossetti-free, Kelmscott was to become Morris's most cherished haven. He also resolved at this time to dissolve the partnership of Morris, Marshall, Faulkner & Co. and buy out his partners so as to take sole control of The Firm. He did this in October, renaming the company Morris & Co. His friendship with Burne-Jones and Webb prevailed but Ford Madox Brown remained extremely bitter about it for many years afterwards. True to form, Rossetti would only agree to the dissolving of the part-nership if his financial compensation of £1,000 was placed in a trust for Jane – a condi-tion he knew would irk Morris.

Morris began delivering a series of lectures that over time became progressively political in content. These were informed by his earlier forays into British industry at Leek and began in 1877 with an address entitled "The Lesser Arts", which was given to the members of the Trades Guild in Oxford. In this, he argued that the decorative arts were more relevant to society than the fine arts because people through necessity interacted with objects for use on a daily basis. He also reaffirmed that decoration should only be used if it had "a use or a meaning" and that the beauty of objects was the sole result of their forms being in accord with nature – not mimicking it. To Morris, a naturalness of form possessed an inherent rightness.

Importantly, through these lectures, Morris was one of the first to promote the idea that "art" would suffer if it were allied with luxury rather than utility and that it should be "popular" or democratic in its appeal. He implored designers to produce well-conceived products that were true to nature and history yet characteristic of the time in which they were made, and insisted that designers and manufacturers had a moral obligation to society to produce objects of quality.

Incensed by Street's unsympathetic restoration of St John the Baptist's Church in Burford and horrified at the proposed restoration of Tewkesbury Abbey by Sir Gilbert Scott, Morris founded the Society for the Protection of Ancient Buildings in 1877

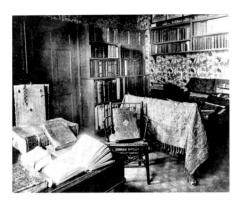

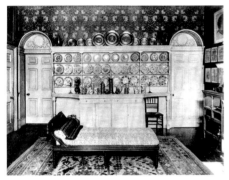

Kelmscott House, 1896
William Morris's study (top) and the
dining room (above)

nicknamed "Anti-Scrape". The SPAB opposed the destruction of original architecture – particularly through insensitive and irreversible restoration – and called for the responsible conservation of intact ancient buildings for the sake of future generations. So strongly did Morris feel about this campaign that from 1877 he refused to supply stained glass to any building undergoing restoration – a line of business that had hitherto been one of the most lucrative for The Firm.

Kelmscott House

In April 1879, while Jane was vacationing in Italy, Morris began house-hunting and eventually leased a large Georgian house overlooking the Thames in Hammersmith. He renamed his new London home Kelmscott House, paying homage to his other cherished riverside home. Having played down the riverside location's main drawbacks of flooding and damp, Morris went on to spend over £1,000 on refurbishments and the resulting interiors were in his mature style. The long drawing room on the first floor comprised an eclectic mix of objects set against the swirling floral patterns of Morris & Co. wallpapers and textiles, while Morris's own study exuded a near-monastic simplicity with its book-lined walls and unpolished oak table.

Since becoming sole proprietor of The Firm in March 1875, Morris had been determined to make a go of it. He desperately needed some financial success: not only had it cost him £3,000 to buy out his partners, but Devon Great Consols was no longer providing any income, as the company had been liquidated the previous year. In 1877, he opened a shop in Oxford Street which marked a new commercial departure for Morris & Co.

Many of the clients who commissioned Morris to design complete interior schemes were either from the aristocracy or wealthy self-made Northern industrialists. It caused Morris endless frustration that he had to spend his time "ministering to the swinish luxury of the rich",[17] yet he knew full well that it was largely this clientele that enabled his business to survive.

Middle-class artistic types also purchased Morris & Co. products, and the Morris "look" became virtually de rigueur for the aesthetes residing in the very fashionable Bedford Park estate built in West London in the late 1870s. In 1877, The Firm began producing woven textiles in rented premises in Great Ormond Yard under the eye of a professional silk weaver recruited from Lyons.

Realizing that any craft discipline required an in-depth knowledge of materials and techniques, Morris researched, experimented in and finally mastered the art of carpet making. He subsequently converted the stable and coach house of Kelmscott House into a carpet workshop-cum-factory for the production of hand-knotted Hammersmith carpets and rugs. Morris also executed carpet designs for Axminster, Wilton and Kidderminster – the mechanized production of which was subcontracted to the Wilton Royal Carpet Factory Co. – and thereby considerably increased the range of products offered by The Firm.

Also at Kelmscott House, Morris turned his attention to tapestry and set up a loom in his bedroom. Having sufficiently mastered the art of weaving, Morris established a weaving workshop at Queen Square that was managed by the young J. H. Dearle. Under Morris's artistic direction, by the 1880s The Firm was retailing a wide and stylistically integrated range of products, which included stained glass, furniture, glassware, tiles, chintzes, wallpapers, embroideries, tapestries, and carpets. Morris & Co.

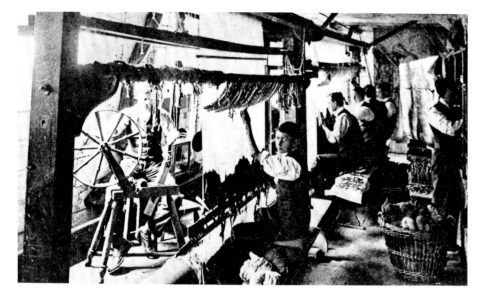

also offered a complete interior design service and promoted an unpretentious, taste-
ful and comfortable "look" that combined the practical with the beautiful. This aesthetic
reflected Morris's dematerialist approach to design and his belief that: "Simplicity
of life, even the barest, is not a misery, but the very foundation of refinement."[18]

A Glimpse of Utopia

In aim to broaden his manufacturing capacity and to lessen his reliance on subcontrac-
tors, Morris began looking for larger workshop premises. The ceramicist William
De Morgan, whose tiles were sold through Morris & Co., eventually found an appropri-
ate site on the banks of the River Wandle at Merton, some seven miles outside London.
The existing buildings there had previously been used for silk-weaving by Huguenot
émigrés. A lease for the works was signed in June 1881 and subsequently the stained-
glass, carpet-making, weaving and dyeing workshops were relocated to this (then)
picturesque setting.

The works at Merton Abbey were run as ethically as possible without compromising
The Firm financially. Morris's employees were better paid, worked fewer hours and
enjoyed significantly better working conditions than was the norm at the time. The ado-
lescent boys who worked in the tapestry workshop were provided with a dormitory to
sleep in and were encouraged to educate themselves through the provision of a circulat-
ing library. Although these boys could have been considered child labour, they were really
following apprenticeships that gave them the opportunity of securing stable careers as
adults. Morris also partially instituted a profit-sharing scheme for his managers, such as
George Wardle. The surrounding meadows at Merton Abbey were used for the drying of
cloth that had been rinsed in the nearby river. The rest of the works' ample grounds were
planted with fast-growing poplars, shrubs and flowers as well as a vegetable garden and
an orchard so as to provide as pleasant a working environment as possible.

Morris got closer to realizing his vision of an idyllic rural working community at
Merton than at any other point in his life, and disseminated the knowledge he gained
there through lectures and articles such as "A Factory as it Might Be" written around
1884, in which he argued for civilized places of work that could be both educational
and pleasurable for their employees. The importance of Merton Abbey cannot be

overstated, for it also offered a three-dimensional blueprint of how ethical issues can be addressed through both the design and manufacturing processes. Morris's inspired experiment at Merton, however, ultimately fell short of his Utopian objectives because it was compromised, he believed, by having to operate within a capitalist system.

To Morris's extreme vexation, the printing of textiles at Merton took some time to perfect. The setting up of a new dye house, weaving sheds and workshop for tapestries and carpets also proved difficult, while the two-hour journey to and from Hammersmith grew evermore tiresome. From 1883, therefore, Morris began to delegate the running of Merton Abbey to George Wardle and the design of wallpapers and textiles for Morris & Co. to J. H. Dearle. This allowed him more time to pursue his other interests, including politics.

Comrade Morris

In the autumn of 1881 Rossetti's health began to deteriorate as a result of his addiction to the lethal combination of laudanum, morphia and whisky. When he eventually died in April 1882, Jane was struck with inconsolable grief. At home, Morris also had the additional worry of his eldest daughter Jenny's worsening epilepsy. Regardless, the early 1880s marked the beginning of a period of intense political activity which was to last nearly a decade. In 1882 Morris read Karl Marx's *Das Kapital* and found much in it that concurred with his own long-held beliefs, including a revolutionary rather than parliamentary approach to politics.

In January 1883, Morris joined the recently formed Democratic Federation, a socialist organization that sought to bring about radical change. Karl Marx's daughter, Eleanor, was a highly active member and this undoubtedly bolstered their revolutionary credentials. Morris abhorred the idea of authoritarian State socialism – his socialist vision could only be brought about by revolution. But given revolution, he believed that if individual freedoms were promoted over the needs and concerns of society as a whole, anarchy would result. Morris's earlier Pre-Raphaelite dream of a medievally inspired Arcadia led him to the idea of glorious revolution and a potentially more realistic vision of a fraternal Utopia.

Shortly after joining the Democratic Federation the zealous Morris became a "street-preacher" for it, and began spreading the socialist message from a soapbox on street corners in all kinds of weather.

Between 1883 and 1884, Morris travelled up and down the country to deliver numerous formal lectures outlining his vision of a socialist and more humanistic future. One of his first lectures, "Art under Plutocracy", which was delivered at University College, Oxford in November 1883, stressed his environmental concerns: "To keep the air pure and the rivers clean, to take some pains to keep meadows and tillage as pleasant as reasonable use will allow them to be... to leave here and there some piece of waste or mountain sacredly free."[19] Morris argued that, as trustees of the shared environment, all men had a responsibility to stem the advance of industrial production which had turned cities into ugly pits of grime-streaked squalor.

In his lecture "Useful Work versus Useless Toil", delivered in early 1884 at the Hampstead Liberal Club, Morris highlighted the parasitic nature of the Victorian bourgeoisie, who profited from the drudgery of the working classes. Morris asserted that it was the mindless production of useless luxuries, which he referred to as "slave wares", that perpetuated the workers' bondage, and proposed that all men should labour worthily.

Morris found himself disagreeing with some of his comrades at the Democratic Federation, which – as the then only true socialist organization in England – harboured a multiplicity of ideas among its members as to what means should be used in the "struggle". A branch of the Democratic Federation was established at Merton and later, on 14 July 1884, a Hammersmith branch was established at Kelmscott House, led by Morris. After a demonstration in Hyde Park in August 1884, the Democratic Federation added the prefix "Social" to its title to placate the revolutionary tendency within its ranks. Differences of opinion arose within the organization over the validity of the parliamentary gradualism and the bloody revolution urged by more radical members, including Morris. Eventually, a ballot to resolve the conflict was held and Morris won 55 per cent of the votes, but promptly resigned.

The Socialist League

Shortly after leaving the Social Democratic Federation, Morris formed the Socialist League with other SDF dissenters including Eleanor Marx. The "Revolutionary International Socialism" advocated by the Socialist League was the means by which class and nationhood would be eradicated and replaced by a global and democratic culture.

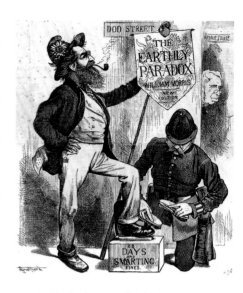

J. P. Stafford, *The Attitude of the Police – The Earthly Paradox*, 1885
Cartoon from *Funny Folks* magazine

Made up of intellectuals, workers and foreign émigrés, the Socialist League supported a no-vote policy and its paper, *Commonweal*, aimed to supplant the SDF's publication, *Justice*, to which Morris had earlier contributed. The League's headquarters were situated in Farringdon Street and by the summer of 1886 it had 19 branches. The Hammersmith branch was the League's spiritual heart, with meetings held in the emptied stables and coachhouse of Kelmscott House.

Earlier in the spring of 1885, the police had arrested some 50 members of the International Socialist Working Men's Club in Stepney, and now began breaking up gatherings of the Social Democratic Federation in Dod Street, a favoured place for meetings. In September 1885 this prompted a 10,000-strong protest in Dod Street in the name of freedom of speech; eight arrests took place. Morris went to the trial to stand bail for those arrested. One of them was an impoverished tailor who was sentenced to two months' hard labour for supposedly kicking a policeman. Outraged at the severity of this sentence, his comrades protested and Morris was arrested in the ensuing scuffle for allegedly hitting a policeman and breaking his helmet. Some two hours later, Morris was brought before a magistrate and when asked who he was, he famously replied: "I am an artist, and a literary man, pretty well known, I think, throughout Europe".[20] He denied any wrongdoing and was subsequently acquitted. Morris's social status had ensured his preferential treatment in court and the irony of this was not lost on commentators, as can be seen in J. P. Stafford's cartoon *The Attitude of the Police – The Earthly Paradox*.

During this period, Morris became associated with the nihilist Sergius Stepniak, and with the early environmentalist and Russian revolutionary Prince Peter Alexeivich, both of whom were leading anarchists. Morris's natural dislike of authority and formal leadership also allowed other extremists to infiltrate the League. With its increasingly disparate factions, the League finally became a shambles.

Despite everything, Morris continued preaching his political gospel and also spread his message through the writing of two socialist pieces, the semi-autobiographical *A Dream of John Ball* (1886–87) and *News from Nowhere* (1889–90). Both of these were first published in instalments in *Commonweal*.

Inspired by Thomas More's *Utopia* of 1516, *News from Nowhere* lays out Morris's personal view of Utopia (Utopia being a Greek name of More's coining, from *ou-topos* meaning "no place"). After the last instalment of *News from Nowhere* had been published, Morris was ousted as editor of *Commonweal*.

A Return to Crafts

Although still politically active, Morris's fervour gave way to stoicism and he returned to his old familiar creative pursuits. He was also the inspirational figurehead of the burgeoning Arts & Crafts Movement, which had been spawned by his earlier urgings for a life lived more simply. Indeed, its members were so galvanized by Morris and Ruskin's teachings that they established workshop collectives such as the Century Guild (founded by Arthur Mackmurdo in 1882) and the Art Worker's Guild (founded by Charles Ashbee in 1884) and went on to become the new vanguard of design reform. In March 1890 Morris went into partnership with The Firm's business managers Robert and Frank Smith, retaining only a 50 per cent stake in the operation. Now less involved in the running of Morris & Co., he had more time to dedicate to creative work. Morris had long been a collector of fine books and he developed an interest in typography. As a result, on 12 January 1891 he rented premises at 16 Upper Mall and established the Kelmscott Press, with the intention of producing beautiful printed works for collectors and lovers of books.

Of the 66 titles published by the Kelmscott Press in small exclusive runs, 23 were written by Morris. These exquisite volumes, which included the great *Kelmscott Chaucer* of 1893–94, were decorated with illustrations by Edward Burne-Jones and Morris's medieval swirling foliate borders and ciphers. The Press used easy-to-read typography, including three new typefaces designed by Morris, and the books it produced helped to bring about a renaissance in art publishing.

In February 1891, Morris suffered a recurrence of gout and a kidney infection. He was very ill, and depressed about the last few years' political turmoil, in which his version of socialism had been sidelined by the Trade Union Movement.

The Hammersmith branch of the Socialist League, including William, Jenny and May Morris, 1885

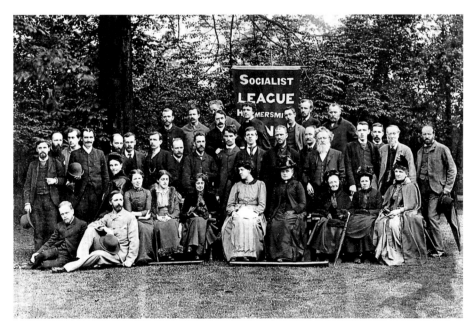

Towards the end of his life, Morris had a political change of heart, coming to view State socialism as a necessary transitional phase on the road to his "communistic" ideal. Although unwell, Morris delivered speeches, wrote poetry and spent time at his beloved Kelmscott Press. In 1896, a physician diagnosed him with diabetes. On his return to England from a four-week voyage to Norway, his health worsened due to the progressive nature of what had now been diagnosed as consumption. On the morning of 3 October 1896, Morris died peacefully in his bedroom at Kelmscott House, aged 62. Reputedly, his last words were: "I want to get mumbo-jumbo out of the world."[21] When his coffin arrived at Lechlade by train, it was placed on a traditional horse-drawn cart decorated with flowers and boughs and borne to the churchyard at Kelmscott, where he was laid silently to rest under a simple tombstone designed by Philip Webb.

Conclusion

For many years afterwards, Morris's influence continued to resonate not only in Great Britain but in the United States and on the Continent as well. Many craft communities were established in America in the late 19th century as the Craftsman Workshops, Roycrofters and the Rose Valley Association, that aspired to his ideals of simple living and handcraft. In Continental Europe, Morris's ideas for craft-based workshops stimulated the foundation of the Darmstadt Artists' Colony, the Wiener Werkstätte, the Deutsche Werkbund and, ultimately, the Weimar Bauhaus. These artistic colonies, however, were not inspired by notions of an escape to a rural Arcadia so much as by Morris's reformism: the supremacy of utility over luxury; the moral responsibility of designers and manufacturers to produce objects of quality; the use of design as a democratic tool for social change. Through the European avant-garde's espousal of these precepts, Morris must be seen as having had a fundamental impact on the early origins of the Modern Movement. But it was Morris's advocacy of a holistic approach to the design and manufacturing processes for aesthetic, social and environmental reasons that was of the most lasting relevance and will remain his greatest legacy.

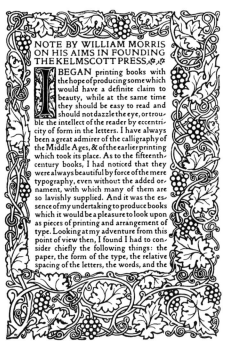

Queen's College Hall, Cambridge, 1863–64
Fireplace

A Note by William Morris on his aims in founding the Kelmscott Press, 1898
Double page from the book

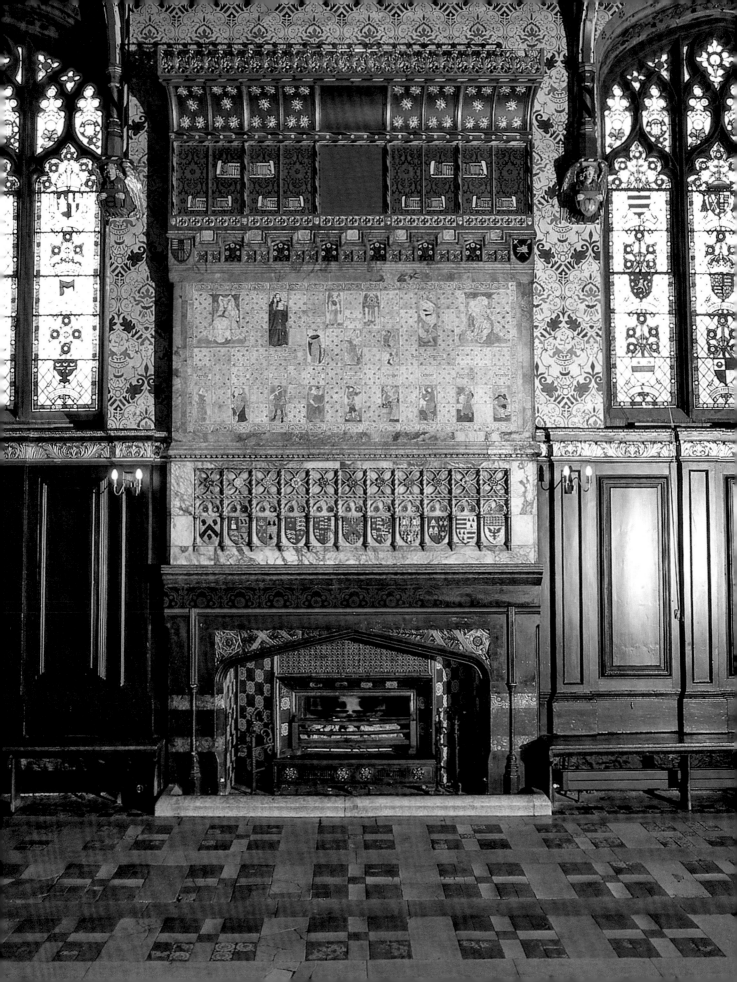

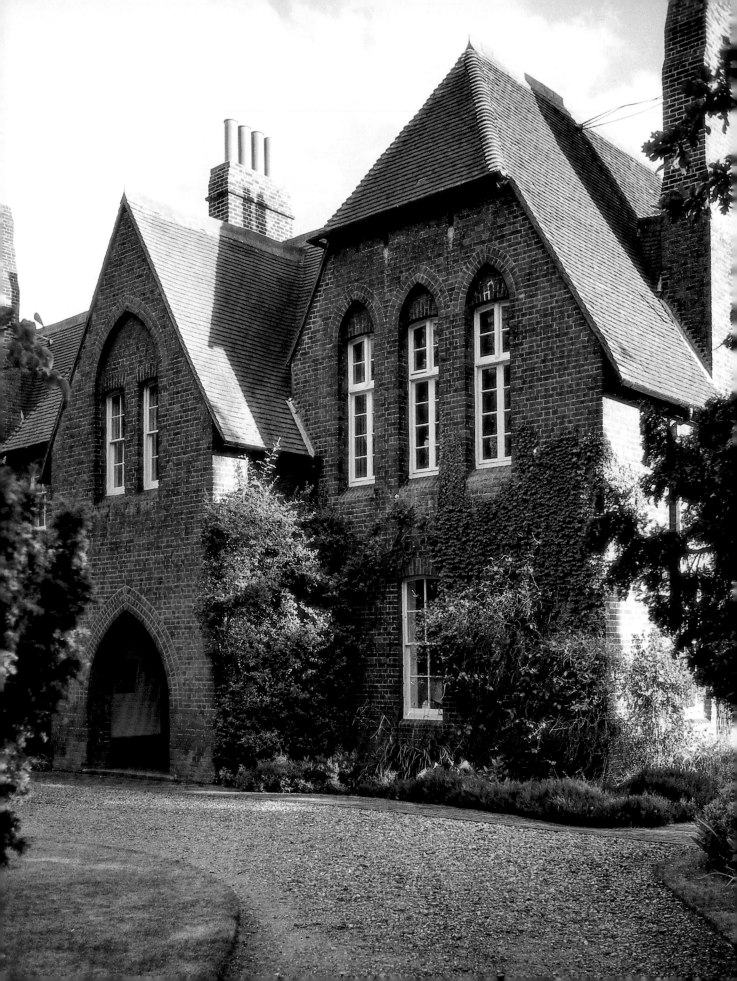

1859–1865 ▸ The Red House
Bexleyheath

First-floor window in the west façade

Opposite page
North entrance

Right
View of the east façade

Morris first discussed plans for the construction of a new house for himself and his prospective wife in August 1858, while on a boat trip on the Seine with Philip Webb. Subsequently, in 1859, the Red House, Bexleyheath was designed by Webb in close collaboration with Morris. The house captured the essence of Early "muscular" Gothic architecture and was revolutionary in that its exterior, including fenestration, was determined by the interior's functional requirements. The practicality of its straightforward floor plan, which linked the rooms by means of a long L-shaped corridor, was extremely influential on a later generation of progressive architects, including Charles Voysey and Charles Rennie Mackintosh, whose revival of domestic architecture would be so acclaimed in Hermann Muthesius' critical study of 1904–05, *Das Englische Haus* (The English House). Georgiana Burne-Jones recalled of the Red House: "It was not a large house but purpose and proportion had been so skilfully observed in its design as to arrange for all reasonable demands and leave the impression of ample space everywhere."[22]

The Red House was planned around an existing orchard so that the minimum number of trees would be felled, and its formal medieval-style garden was designed to

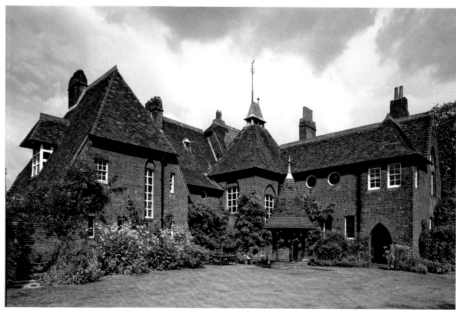

be in complete harmony with the building. In late summer apples would even fall through the windows, much to the delight of Morris's guests. Philip Webb also designed an extension to accommodate the Burne-Jones family and The Firm's workshops; had it been built, the courtyard would have been closed on all sides to form a large quadrangle, while the internal corridor would have functioned like an enclosed cloister. The hooded well, although operative, was conceived primarily as a focal point and provided the building with a strong sense of domesticity. The unpretentious exterior of the building, with its understated Gothic elements, belied the richly decorated interiors within. These were adorned with murals by Rossetti and Burne-Jones, stained glass and painted medieval-style furniture, including the earlier pieces from Red Lion Square. The interior scheme, however, was perhaps too avant-garde for some. William Scott-Bell noted: "The total effect was strange and barbaric to Victorian sensibility and the adornment had a novel, not to say, startling character, but if one had been told that it was the south sea island style of thing one could have believed such to be the case, so bizarre was the execution."[23]

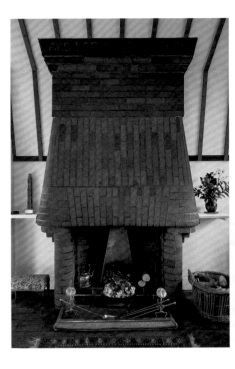

The Studio later described the Red House as "that wonderful red building which proved to be the prototype of all the beautiful houses of the so-called 'Queen Anne' revival; although that house, it may be said in passing, is almost entirely Gothic, with strong French influence apparent".[24] Certainly, it was one of the first domestic buildings to revive the use of unadorned brickwork and this, too, was an enormously influential feature of its design. Of greatest significance, however, was Morris's holistic approach to the project: its garden, architecture, interiors and furnishings were designed organically as a homogenous whole. As such, the Red House can be seen as an early embodiment of a *Gesamtkunstwerk* (unified work of art).

Morris never again visited the Red House after he and his family moved back to London in the autumn of 1865. Perhaps a return to his beloved "palace of art" would have been too painful an experience.

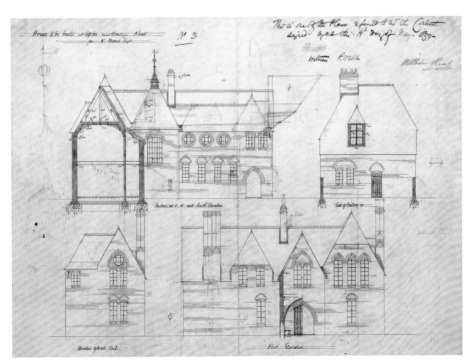

Above
Fireplace in the first-floor drawing room

Left
Philip Webb, Drawing of the north and south elevations of the Red House, 1859

Opposite page
Table and dresser (designed by Philip Webb) in the dining room

34

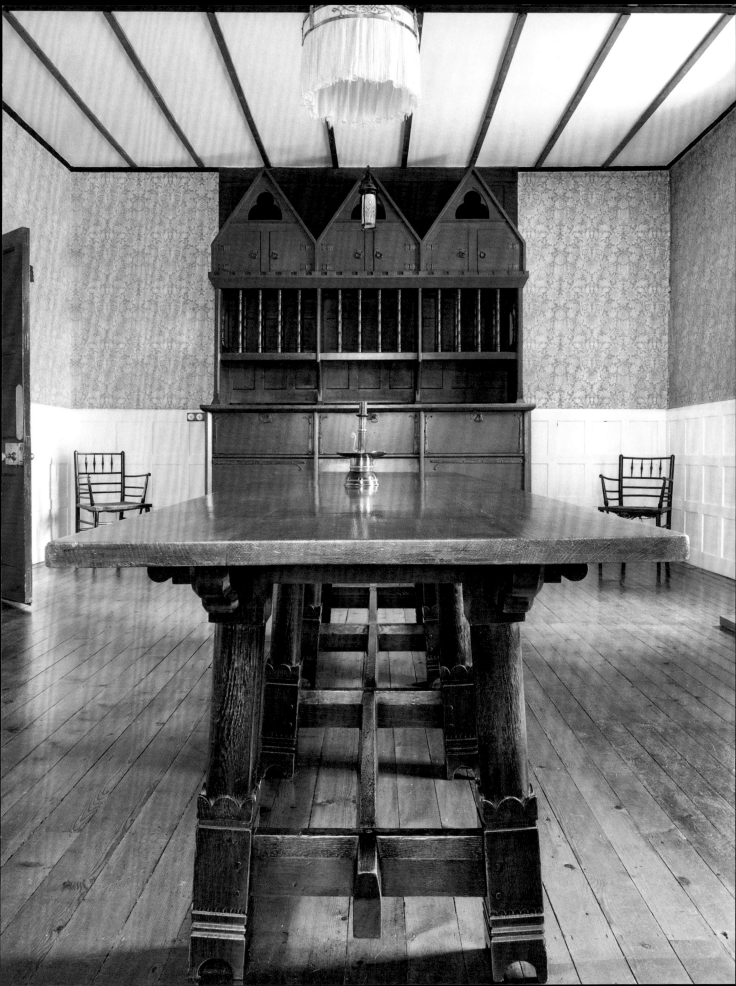

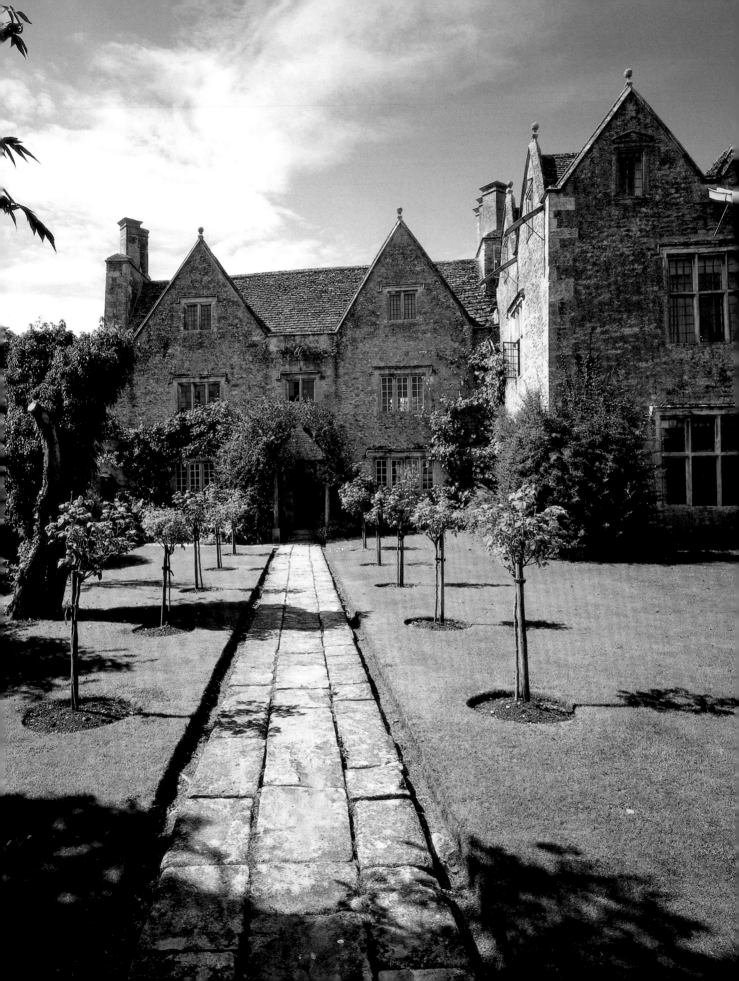

1871–1896 ▸ Kelmscott Manor
Kelmscott

In May 1871, Morris and Rossetti agreed to sign a shared lease on a country residence that had been advertised in a London estate agent's catalogue. The property, Kelmscott Manor, was a beautiful Elizabethan stone house set picturesquely in a small rural hamlet on the edge of the Cotswolds. Rented by Morris from 1871 until his death in 1896, this riverside home was Morris's most cherished haven for over 25 years and was the inspiration for his Utopian novel, *News from Nowhere* (1889–90).

In 1874, Rossetti left Kelmscott and his half of the tenancy was taken over by Morris's publisher, F. S. Ellis. Eventually, in 1913, Jane purchased Kelmscott Manor and nearly ten acres of surrounding land for £4,000. May, the Morrises' daughter, continued living there until her own death in 1938 when, under the terms of her will,

Opposite page
East façade from the garden

Right
**South corner of the west façade
from the garden**

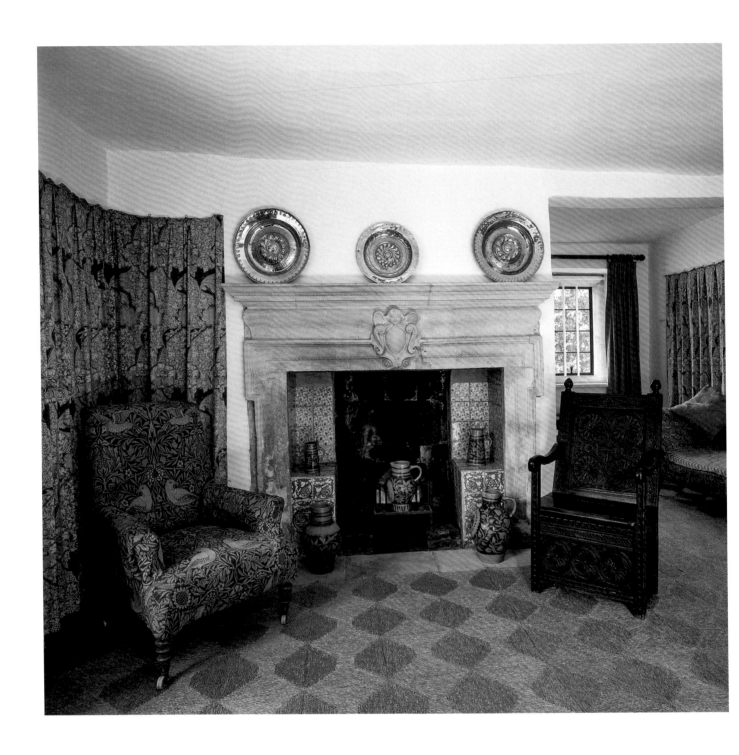

the house and grounds were put in trust to the University of Oxford. This bequest, however, was later deemed invalid, and in 1962 the property was passed over to the Society of Antiquaries, the residuary legatee of the Morris estate, which has in recent years painstakingly restored the interiors to some of their former glory.

The original H-shaped building, built between 1580 and 1630, was a farmhouse that followed a recognizable medieval plan. Although a northeast wing was added slightly later in the 17th century, providing more spacious accommodation, the house was little altered over the succeeding years. Morris used Kelmscott Manor primarily as a holiday home, and as its tenant made few changes to the fabric of the building.

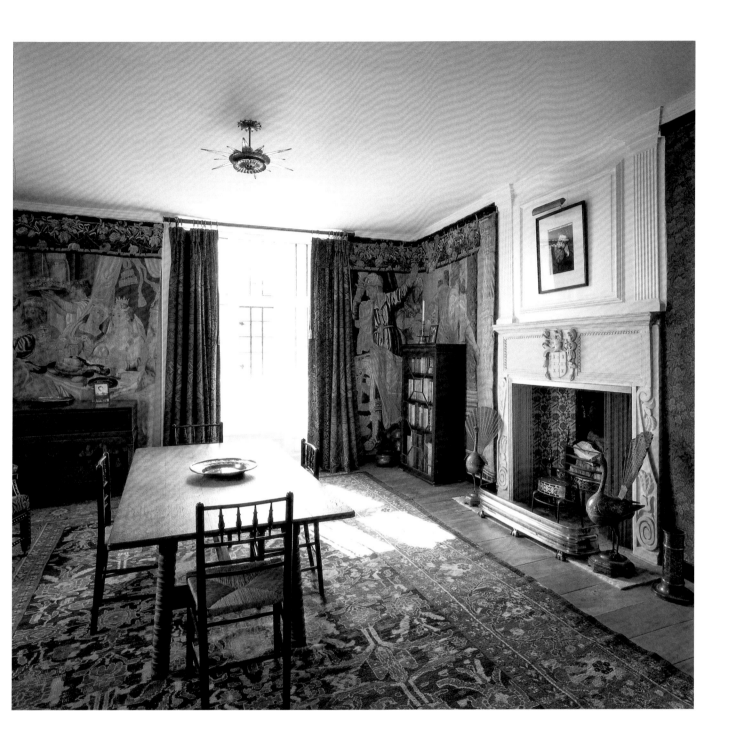

Opposite page
Fireplace in the Green Room

Above
The Tapestry Room
View to the south

He did, however, decorate it with sympathetic furnishings, many of which were sadly displaced after his death. The interiors that exist today were reconstructed using furniture left over from his tenancy as well as additional items gathered from his various London residences. A number of the more exotic *objets d'art* that decorate the Manor belonged to Rossetti.

The Green Room, a sitting room on the ground floor, exemplifies Morris's approach to interior design. Here, the simple and uncluttered space is decorated with an eclectic mix of period objects and other items produced by The Firm, together with Morris's early medieval-style *If I Can* embroidered hanging. The Tapestry Room on the first

floor was and still is hung with four 17th-century tapestries depicting the life of Samson. Initially used by Rossetti as a studio, this long room was originally furnished with a gate-leg table and Sussex chairs. The main bedroom used by Morris, however, has been little altered and retains its 17th-century carved oak four-poster bed adorned with hangings embroidered by May Morris. The embroidered pelmet of the bed was worked with a verse specially composed by Morris that reveals his deep affection for Kelmscott Manor.

In the attics at the top of the Manor, amongst the great roof timbers, small garret rooms were used as bedrooms by Jenny and May. These were furnished with simple utilitarian green-painted furniture that was designed in the early years of Morris, Marshall, Faulkner & Co. by Ford Madox Brown. Just as these and the other unpretentious interiors at Kelmscott Manor were completely in tune with the rural character of the building, so too was the semi-formal front garden. With its avenue of roses, this garden is important in its own right as an early example of first-phase Arts & Crafts garden design.

Below
Jane Morris's jewel casket, probably designed by Philip Webb and painted by Lizzie Siddal and Dante Gabriel Rossetti

Opposite page
William Morris's bedroom

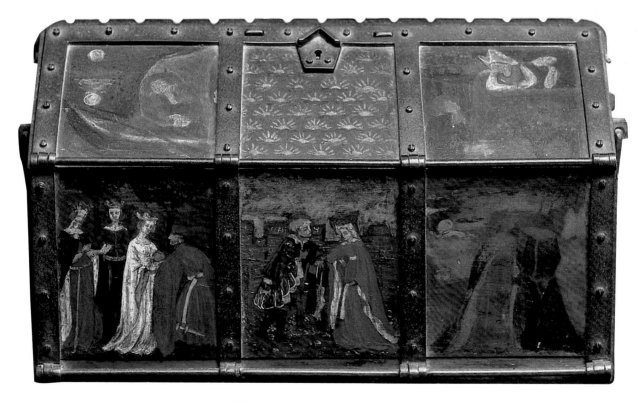

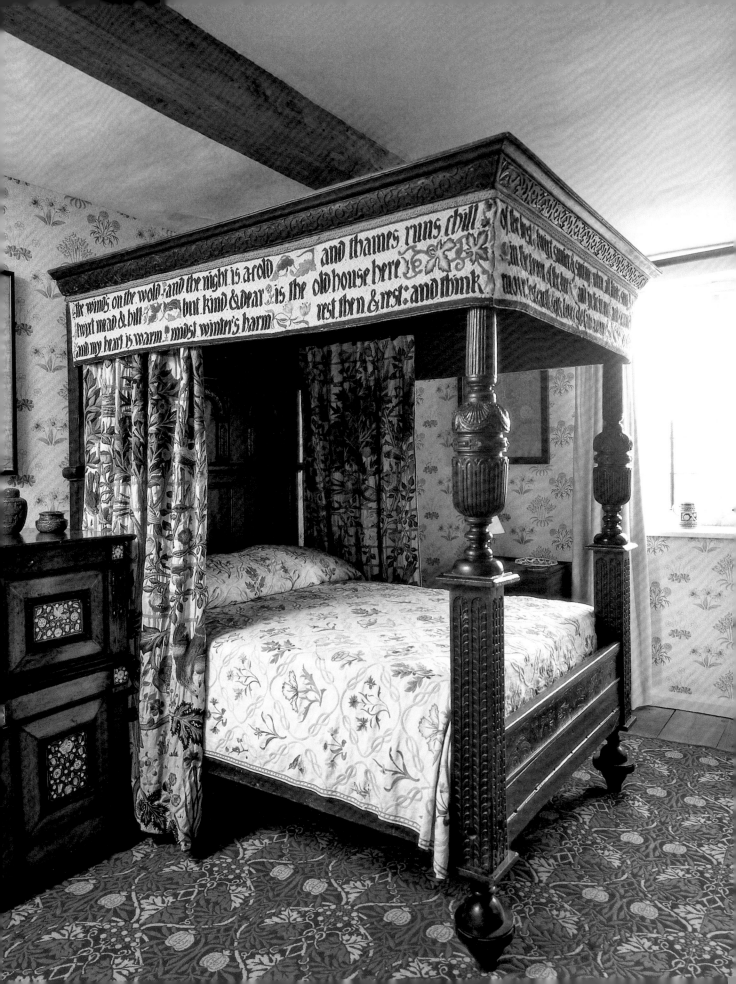

The wind's on the wold · and the night is a-cold
twixt mead & hill · but kind & dear · is the old house here
and my heart is warm · midst winter's harm · and thames runs chill
rest then & rest: and think

1878–1896 ▸ Kelmscott House
Hammersmith

Below
The drawing room, east view, 1896

Opposite page, above
North wall of the drawing room, 1896

Opposite page, below
William Morris's study, 1896

This Georgian property at 26 Upper Mall, Hammersmith was originally known as The Retreat, but Morris renamed it Kelmscott House in tribute to his other riverside home. Overlooking the Thames, the property was rented from the children's author and poet Dr. George Macdonald, whose family of 11 children had previously occupied it. After the Morris family moved in, a carpet factory was set up in the stables and coach-house, and later, when this workshop moved to Merton Abbey, the space was used for Morris's political meetings.

Having spent nearly £1,000 on the redecoration of the property, the Morris family moved into Kelmscott House in November 1878. The interiors had either woven textile hangings or swirling floral wallpapers, with only a few pictures adorning the walls. The furniture ranged from heavy medieval-style pieces such as the *The Prioress's Tale* wardrobe and Webb's settle, both of which were positioned in the first-floor drawing room, to more commercial Morris & Co. designs such as Webb's adjustable Morris chair and

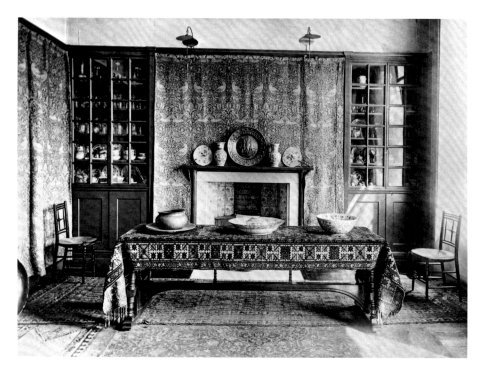

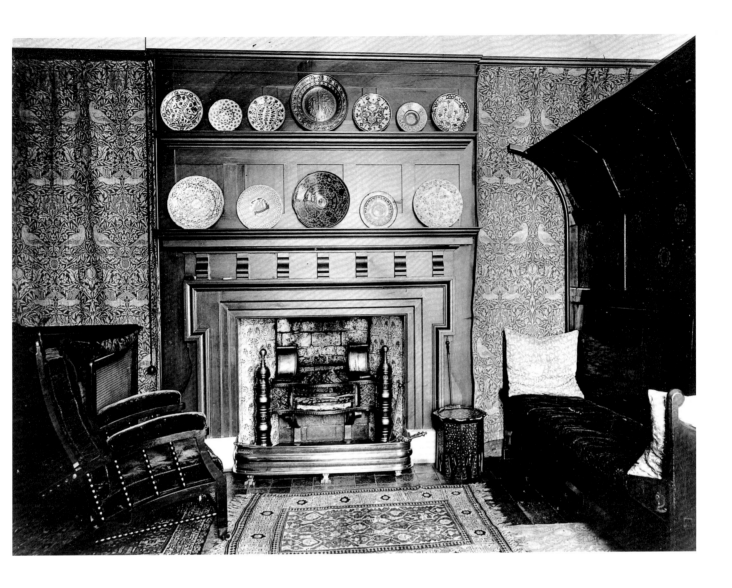

Sussex chair. The richness of these interiors was achieved by the addition of lustre plates, Persian carpets, eastern brassware and Morris & Co. rugs. While the overall effect was distinctly masculine and conveyed a sense of connoisseurship rather than luxury, the light and relatively restrained aesthetic of the rooms was quite a departure from the mainstream Victorian taste for cluttered interiors with quantities of trinkets and heavy layers of dark curtaining. Although still used as a private residence, the basement of Kelmscott House is now the home of the William Morris Society.

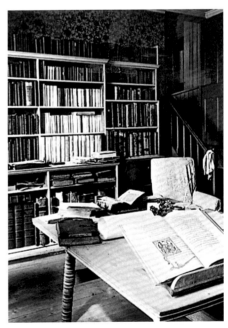

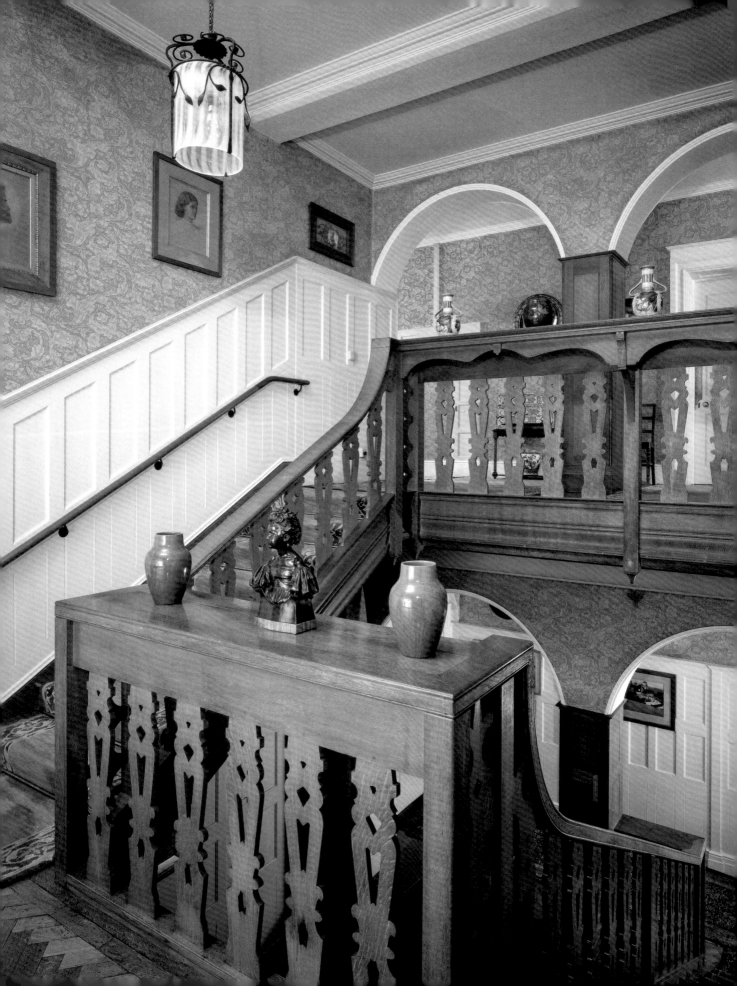

1891 ▸ Standen
Sussex

Opposite page
The staircase

Below
The drawing room, seen from the hall

J. S. Beale, a successful solicitor and friend of the Ionides family, commissioned Philip Webb to design a house for him near East Grinstead, Sussex, in 1891. The unostentatious Standen, like the Red House, was inspired by vernacular building types and was built to a similar L-shaped plan. Many of its rooms were papered with Morris & Co. designs, while the dining room was decorated with woven Morris & Co. curtains and the drawing room furniture was covered with Morris & Co. chintzes. Standen can be considered a quintessential Arts & Crafts house and is one of the best surviving examples of the Domestic Revival – a style of architecture that was pioneered by Morris and Webb at the Red House.

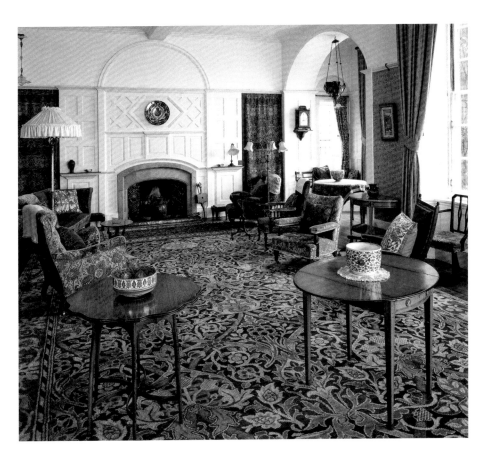

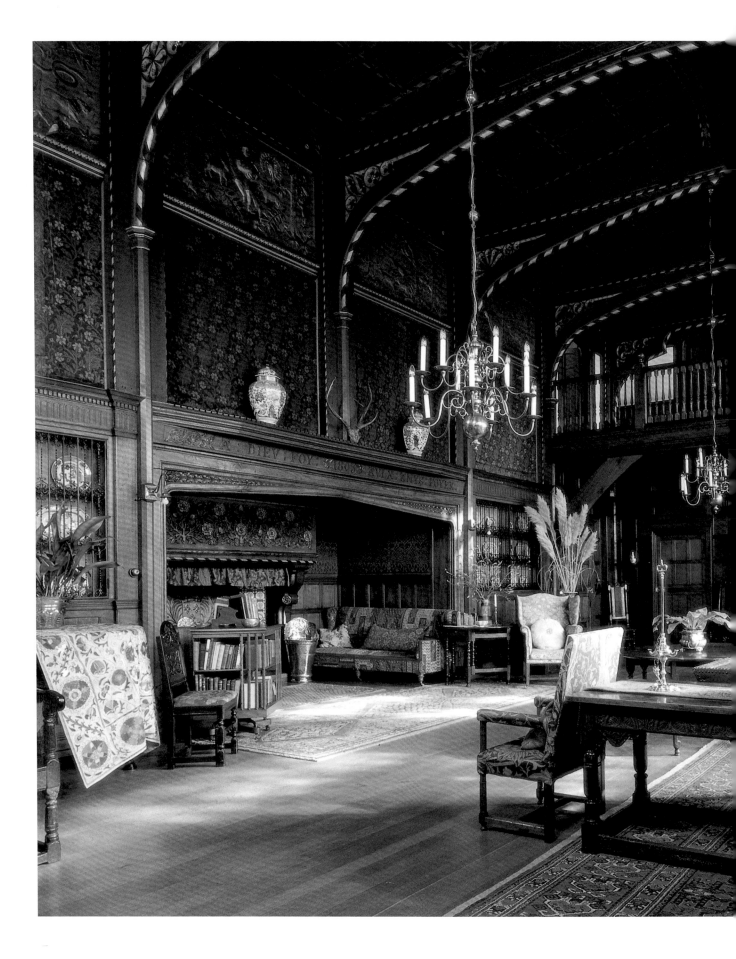

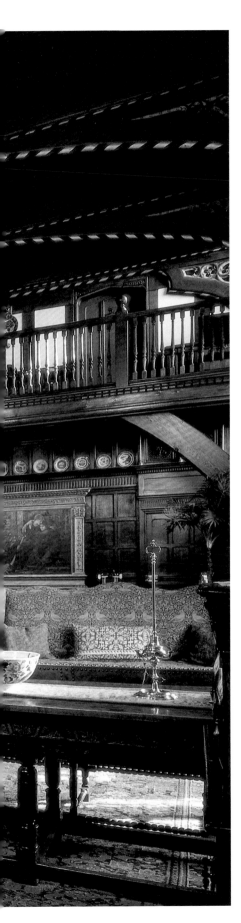

1887 ▸ Wightwick Manor
Wolverhampton

In 1887 Theodore Mander, a wealthy paint manufacturer, purchased a property three miles from his native town of Wolverhampton and shortly afterwards commissioned the architect Edward Ould to design a new house for the site. The resulting building, which was extended in 1893, was half-timbered and in the Tudor Revival style. A profusion of upholstery textiles, hangings, embroideries and tiles by Morris & Co. was used throughout the Manor's interior. In addition to this, the hall was decorated with stained-glass panels inspired by characters from Morris's *The Earthly Paradise*, albeit designed by the Gothic Revivalist C. E. Kempe. The decorative arrangement of the richly masculine Great Parlour combined the baronial with the homely, while the other interiors at the Manor imparted a sense of comfort and quality rather than luxury. Over a period of 40 years, The Firm continued to supply an array of designs for the house, ranging from tapestries to light fixtures, and its interior scheme may thus be considered truly representative of the Morris & Co. aesthetic.

The Great Parlour

Above and opposite page
Ford Madox Brown, *Architecture* and *Music* (two scenes from *King René's Honeymoon*), stained-glass panels, *c.* 1863

Shortly after Morris, Marshall, Faulkner & Co. was founded in 1861, a kiln for firing glass was installed in its premises at 8 Red Lion Square. A professional glass painter and an experienced glazier were engaged and young assistants were recruited from the Industrial Home for Destitute Boys. By 1862 there was a team of twelve workers producing designs for stained glass, and it was in this area that The Firm received the majority of its earliest commissions. Morris, Marshall, Faulkner & Co. showed several stained-glass panels at the 1862 International Exhibition held at South Kensington, and so well did these capture the spirit of ancient archetypes that some of The Firm's competitors accused it of exhibiting original medieval work.

Unlike the majority of manufacturers, who produced panels that were the equivalent of stained-glass paintings and which relied heavily on shading, The Firm's windows, like those of the Middle Ages, accentuated the mosaic-like qualities of the medium. Excelling as a colourist, Morris juxtaposed different subtly toned and patterned pieces to create exquisite panels of immense richness. Although stylistically inspired by Pre-Renaissance work, The Firm's designs should be regarded as essentially Pre-Raphaelite and not as Gothic reproductions. Many of the stained-glass panels were collectively designed, with Burne-Jones being responsible for the execution of the figures and either Morris or Webb creating the backgrounds. For Morris, the function of stained glass was to "tell stories in a simple direct manner".[25] Religious subjects in The Firm's designs, in particular the saints, were not charged with the piety so often found in mainstream Victorian stained glass. Instead, The Firm took a straightforward narrative approach and produced designs that conveyed that sense of humanity that is so characteristic of Pre-Raphaelite painting.

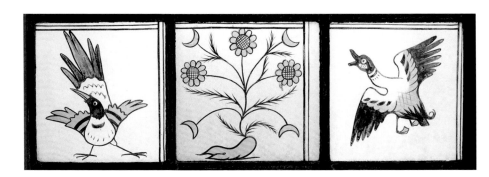

Philip Webb, Stained-glass panel possibly designed for the nursery at the Red House, *c.* 1859–60

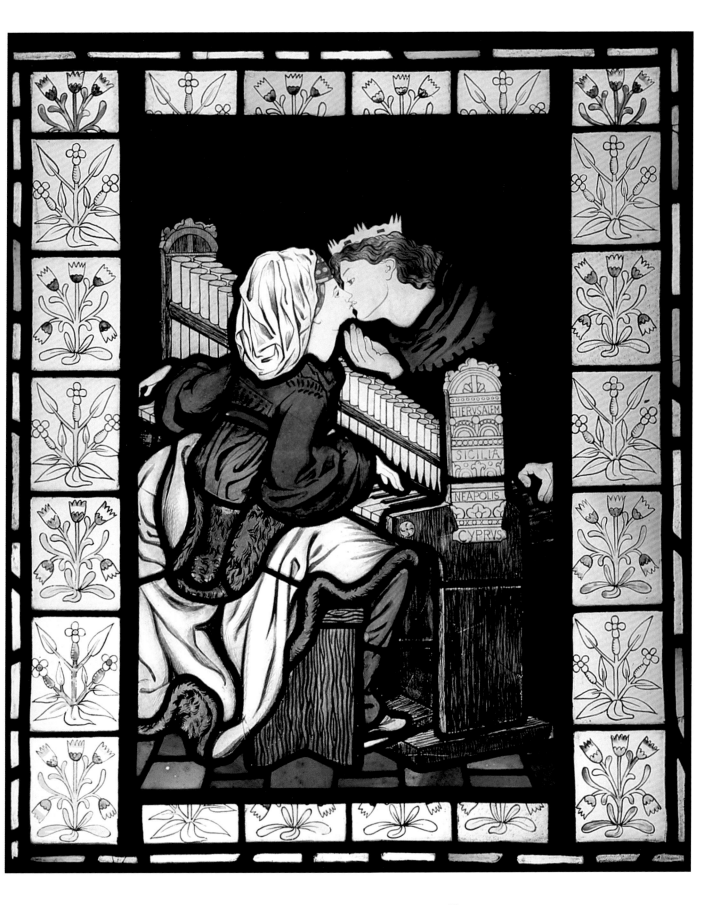

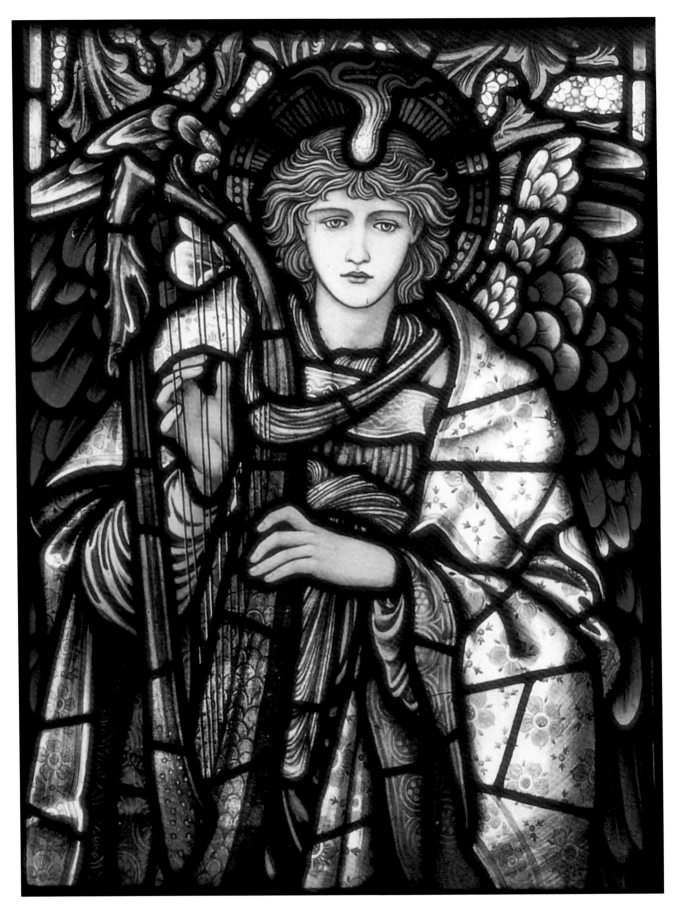

Opposite page
Edward Burne-Jones, *Angel with Harp*, stained glass, 1885

Opposite page
Edward Burne-Jones, *Angel with Harp*, stained glass, 1885

Right
Edward Burne-Jones, *Amor & Alcestis* (scene from Chaucer's *Legend of Goode Wimen*), stained-glass panel, 1864

Below
Morris & Co., *Spring*, stained-glass panel, designed for the dining room at Richard Norman Shaw's Cragside, 1873

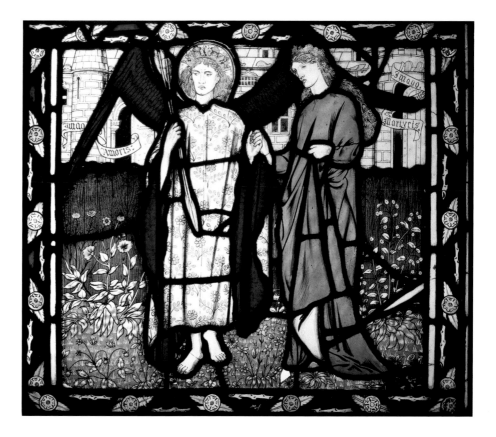

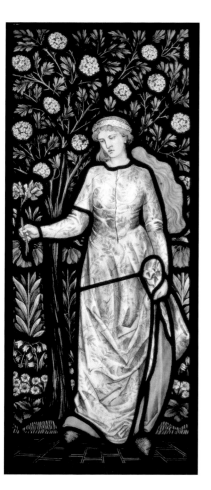

The 1860s was a period of intensive church building, which brought Morris, Marshall, Faulkner & Co. numerous commissions for stained glass, from Gothic Revival architects such as George Edmund Street and George Frederick Bodley. The first such commission was for Bodley's All Saints' Church in Selsey in 1861. The Firm also designed stained-glass windows and panels both for Gothic Revivalist restorations of old churches, and as memorials, which Morris later referred to as "grave stones".[26]

After founding the Society for the Protection of Ancient Buildings in 1877, Morris refused to supply stained glass to any medieval building undergoing restoration – a line of business that had previously accounted for a third of The Firm's stained glass work. After this, many incorrectly believed that Morris & Co. had entirely abandoned the manufacture of stained glass, and the volume of commissions fell to such an extent that Morris had to place advertisements in various journals to set the record straight. During the 1880s and 1890s, The Firm's designs for stained glass became more pictorial and less medieval in style. Importantly, Morris & Co. revived stained glass art and craftsmanship and in so doing inspired a renaissance of the medium that was perpetuated by the Arts & Crafts Movement.

c. 1856– ▸ Furniture

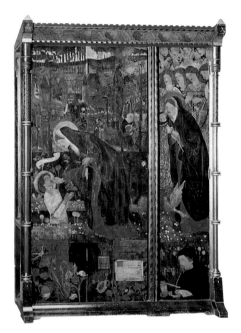

Edward Burne-Jones, "The Prioress's Tale" wardrobe, 1858

Opposite page, above
Philip Webb (design) & William Morris (decoration), "Legend of St George" cabinet, 1861–62

Opposite page, below
John Pollard Seddon, "King René's Honeymoon" cabinet, decorated with panels executed by Morris, Marshall, Faulkner & Co., 1861–62

Morris's earliest-known furniture designs are those he produced between late 1856 and early 1857 for the three-roomed bachelor accommodation he shared with Edward Burne-Jones at 17 Red Lion Square. This solidly constructed and medievally inspired furniture, which was built for Morris by a local cabinetmaker, included two high-backed chairs and a large round table (now in the Cheltenham Art Gallery & Museum). The chairs were painted by Rossetti, Burne-Jones and Morris with chevron motifs and scenes from Morris's "Sir Galahad, A Christmas Mystery", a poem that glorifies an Arcadia inhabited by chivalrous knights and fair damsels. The Weaving chair designed by Morris, with rustic painted decoration and a crude plank construction, most probably dates from this period as well. The Red Lion Square furniture also included an enormous settle reputedly carved in part by Morris himself, and a "throne" chair that was topped with a box-like element that Rossetti suggested would be perfect for keeping owls in.

When Morris and his young wife, Jane, moved into the Red House in June 1860, some pieces of furniture were specially produced for the interior. Most of these were designed by Webb and included a dresser, a settle that incorporated cupboards, and two trestle tables, one of which served as a prototype for a later design manufactured by Morris & Co. The Red House was also furnished with rush-seated chairs which were probably early examples of Sussex chairs, and with Edward Burne-Jones' wedding gift to the Morrises, "The Prioress's Tale wardrobe which was a forerunner of the painted furniture designs exhibited by The Firm in 1862. Morris's experience in overseeing the interior design of the Red House and the furniture produced for it was a prime motivating factor in his formation of Morris, Marshall, Faulkner & Co. in 1861.

Although The Firm was established with the objective of designing, manufacturing and retailing high quality artistic goods, its partners from the outset intended that its products should be non-elitist and wide-ranging in their appeal. Rossetti wrote in January 1861 that the aim of The Firm was to "give real good taste at the price as far as possible of ordinary furniture".[27] The furniture exhibited by Morris, Marshall, Faulkner & Co. in the Medieval Court at the 1862 International Exhibition in South Kensington was, however, far from ordinary in style or cost. The richly decorated "Legend of St George" cabinet, for example, was very expensively priced at 50 guineas and far beyond the means of all but the wealthiest.

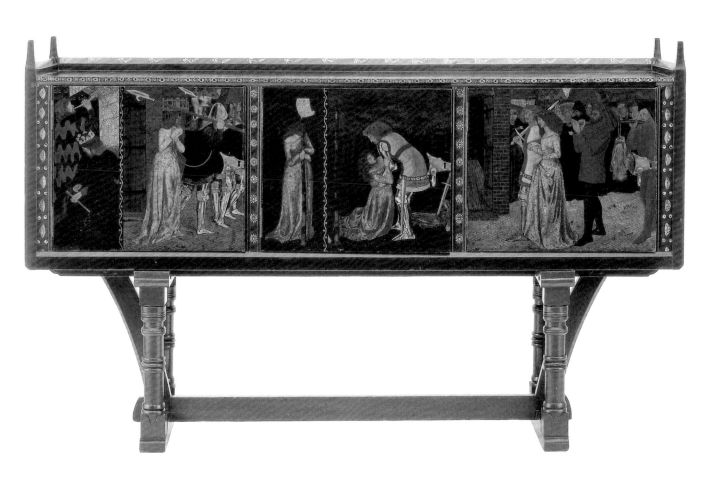

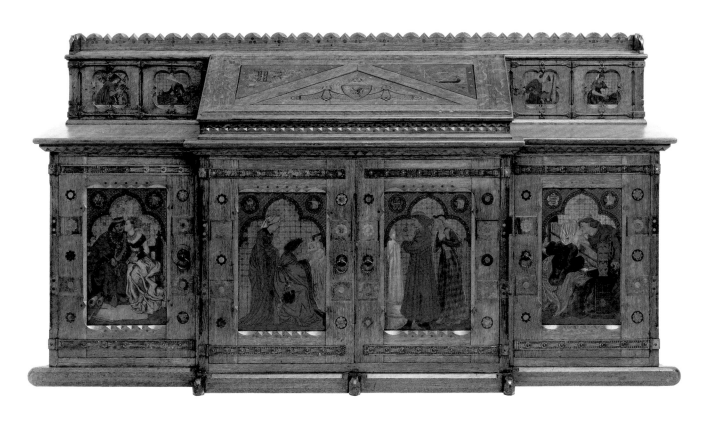

53

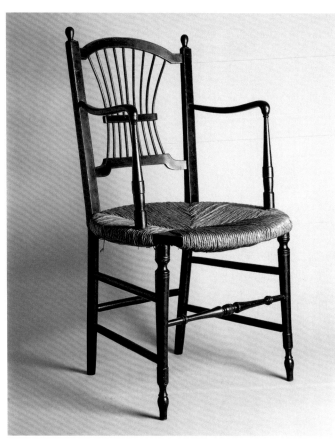

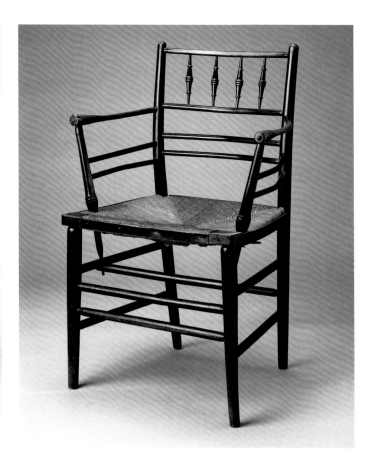

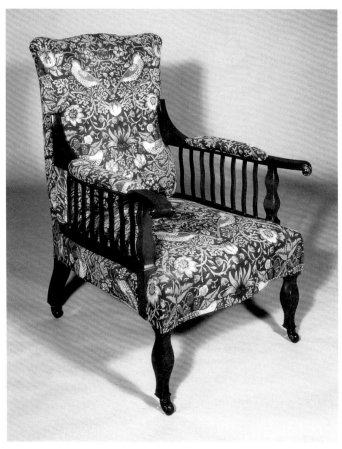

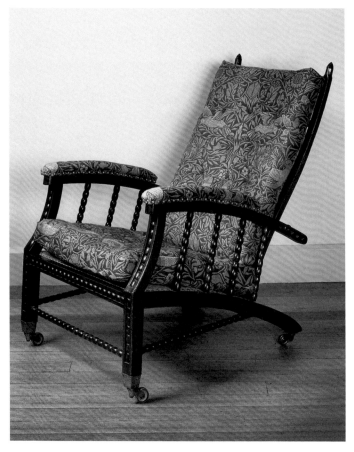

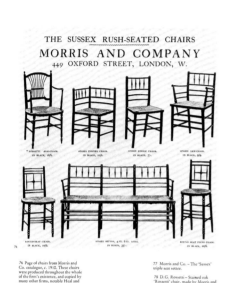

76 Page of chairs from Morris and Co. catalogue, c. 1910. These chairs were produced throughout the whole of the firm's existence, and copied by many other firms, notably Heal and Sons.

77 Morris and Co. – The 'Sussex' triple seat settee.

78 D.G. Rossetti – Stained oak 'Rossetti' chair, made by Morris and Co.

79 Ford Madox Brown – Stained chair with rush seat, made by Morris and Co.

The Sussex range, illustrated in the Morris & Co. catalogue, c. 1915

Opposite page, above left
Dante Gabriel Rossetti, Rossetti armchair, c. 1864–65

Opposite page, above right
Ford Maddox Brown (attributed), Sussex chair, c. 1864–65

Opposite page, below left
George Jack, Saville chair, c. 1890

Opposite page, below right
Philip Webb, Adjustable Morris & Co. chair, upholstered with "Bird" textile, produced c. 1866

From the mid-1860s, alongside their sumptuously painted and carved furniture, The Firm began to produce simpler and more affordable designs, such as the Rossetti armchair. During these early years, Webb designed the majority of The Firm's case furniture and tables and in 1867 he was formally appointed Morris, Marshall, Faulkner & Co.'s furniture manager. His Reformed Gothic furniture designs were a response to George Edmund Street's appeal for pieces of furniture that were "really simple, with no more material consumed in their construction than was necessary for their solidity".[28] Much of this early furniture was manufactured in The Firm's own workshops in Great Ormond Yard, while from 1881 furniture production was undertaken at Merton Abbey.

The Firm's most commercially successful furniture was the Sussex range of chairs. These are generally attributed to Ford Madox Brown, who reputedly discovered their antique archetype in a shop in Sussex. Produced from around 1865 until the closure of The Firm in 1940, the Sussex chairs were competitively priced at a modest 9/- around 1912. The success of this type of lower cost vernacular furniture, which Morris described in 1882 as "good citizen's furniture" and "necessary work-a-day furniture, which should be of course both well made and well proportioned",[29] contributed to the birth of the Arts & Crafts Movement.

The introduction of more accessible "cottage" furniture to The Firm's product range coincided with George Warington Taylor's appointment as business manager and his re-organization of the company. Indeed, Warington Taylor believed that "it is hellish wickedness to spend more than 15/- in a chair, when the poor are starving in the streets".[30] The Firm nevertheless also continued to produce more expensive and elaborate furniture that revelled in traditional craft techniques, such as carving, inlaying and painting. Morris believed in the validity of this exclusive high-style "state-furniture", because he saw it not only as a means of promoting the handicrafts but also as a medium through which skilled workers could be meaningfully employed. This type of highly ornamented furniture was produced by The Firm "as much for beauty's sake as for use", and was regarded by Morris as "the blossoms of the art of furniture".[31]

In 1890 The Firm acquired a furniture factory from Holland & Son. Situated in Pimlico, it was subsequently managed by George Jack, who took over from Philip Webb as Morris & Co.'s chief furniture designer. Jack's tenure marked a stylistic departure for The Firm's furniture range, as he instigated a return to more traditional cabinetmaking methods and produced designs that were more suited to contemporary bourgeois taste. This furniture was inspired by the Regency style and was often decorated with marquetry. Unlike Webb, who favoured oak, Jack's preferred material was mahogany, which he used to great effect in furniture designs such as his Saville chair of around 1890.

c. 1862– ▸ Tiles

Edward Burne-Jones, "Didonis" tile, *c.* 1863

One of The Firm's earliest technical and commercial successes was with its decorated tin-glazed earthenware tiles. From around 1862, Morris, Burne-Jones, Rossetti and Ford Madox Brown produced designs for tile panels depicting scenes from ancient legends, fairy tales or months of the year. These designs were subsequently hand-painted with enamel paints onto blank white tiles, imported from Holland, by associates of The Firm, such as George Campfield, Lucy Faulkner, Kate Faulkner, and on occasions Georgiana Burne-Jones and even Morris himself. Once the tiles had been painted they were re-fired, initially in a kiln set up in the basement of Morris, Marshall, Faulkner & Co.'s premises in Red Lion Square. The tiles, which were intended for both interior and exterior use, were most frequently arranged as panels and used on the walls of entrance porches, fireplace surrounds and mantels. The figurative imagery depicted in these panels revived the narrative tradition in Renaissance maiolica ware.

Other tiles, many of which were designed by Morris and Webb, were conceived as repeating patterns and were inspired by 18th-century Delft tiles. In the mid-1870s, probably for technical reasons, the production of some of these highly popular repeating pattern tiles was transferred to Dutch manufacturers, such as Ravesteijn in Utrecht. It seems that The Firm had difficulty in achieving good results from the enamels commercially obtainable in the 1860s. This was due in all likelihood to the enamels having too high a borax content. Around 1870, however, improved colours came onto the

Right and opposite page, from left to right
William Morris (attributed),
"Pink & Hawthorn" tile, 1887
William Morris, "Tulip & Trellis" tile, 1870
William De Morgan, "BBB" tile from the
Chelsea period, *c.* 1875

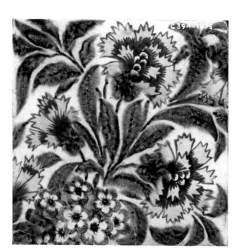

No. 1.

PAINTED TILES FOR STOVES, HEARTHS, WALLS, etc.

From MORRIS & COMPANY, 449, Oxford Street, LONDON.

Right
**Morris & Co., Broadsheet showing
the range of De Morgan tiles retailed by
The Firm, undated**

Right
**Morris & Co., Broadsheet showing
the range of De Morgan tiles retailed by
The Firm, undated**

Following spread
**Edward Burne-Jones & William Morris,
"Sleeping Beauty" panel of tiles, 1862–63**

market and were supplied by William De Morgan, who produced designs for The Firm from 1863.

Confusingly, De Morgan designed tiles that were manufactured by The Firm, while at the same time producing tiles designed by members of The Firm at his own pottery in Chelsea. From the early 1880s, De Morgan's new pottery, which was sited adjacent to Morris's own works at Merton Abbey, manufactured the majority of tiles designed by The Firm. Many of De Morgan's own tiles, most of which were decorated with either strange mythical creatures, exotic intertwining flora or galleons on stormy seas, were retailed by Morris & Co.

Of a certain Prince who delivered a King's daughter from a sleep o

red years, wherein she & all hers had been cast by enchantment

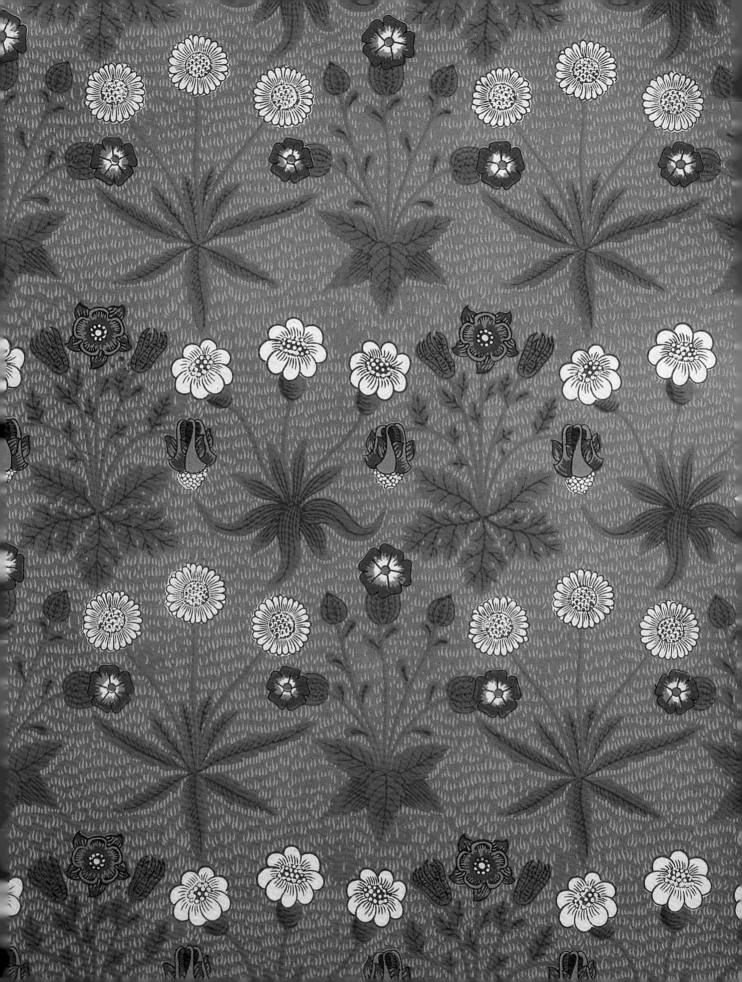

1864– ▸ Wallpapers

Morris designed his first three wallpapers – "Daisy", "Fruit" and "Trellis" – between 1864 and 1867 and initially intended to produce them with zinc plates. Finding this process too time-consuming, he eventually turned to Barrett of Bethnal Green, a firm of block cutters, to cut traditional blocks out of pear wood for their production. Morris's early designs countered the mainstream Victorian taste for the florid "French" style of the early 1850s and the "Reformist" style popularized by A. W. N. Pugin and Owen Jones from the mid-1850s. The latter style of wallpaper patterning was characterized by a geometric uniformity that emphasized the two-dimensionality of the medium. While Morris's designs were non-illusionistic – thus remaining true to their materials – his naturalistic patterned repeats flowed freely and seamlessly into one another to create rhythmic and balanced overall patterns. The block printing of these early and relatively straightforward wallpaper designs was subcontracted to a technical specialist, Messrs Jeffrey & Co. of Islington, who would also execute the later more complex Morris & Co. designs.

Opposite page
"Daisy" wallpaper, registered 1864

Right
**"Trellis" wallpaper, designed 1862, issued 1864
(birds drawn by Philip Webb)**

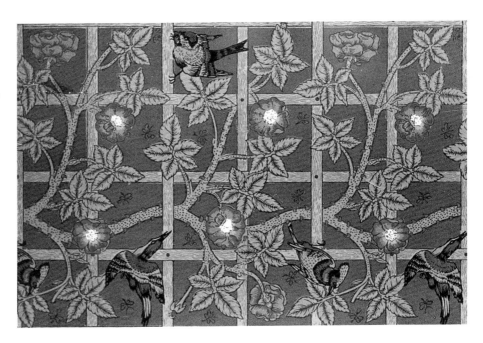

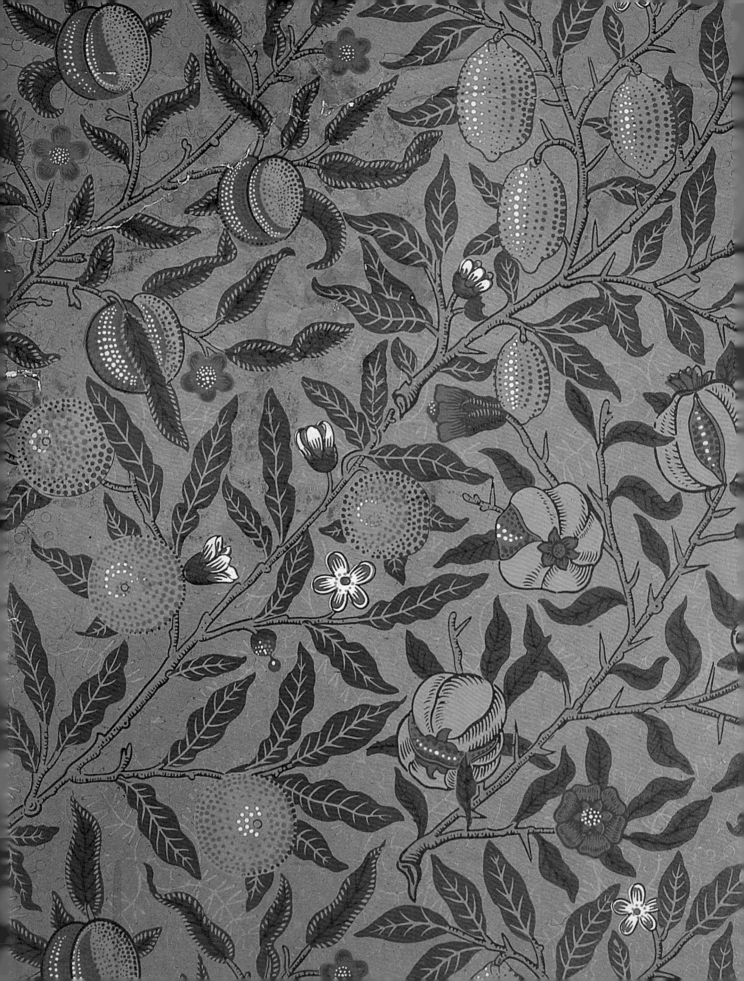

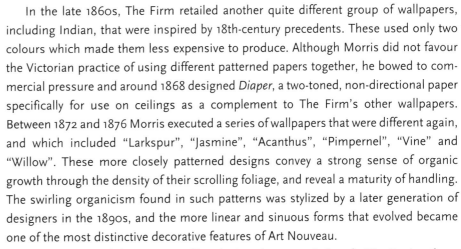

"Fruit" or "Pomegranate" wallpaper, issued *c.* 1866

Morris & Co. log book, maintained by Jeffrey & Co., *c.* 1865–93

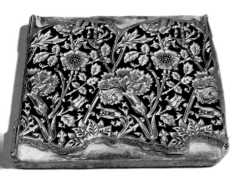

Printing block for "Pink & Rose" ceiling paper, designed by William Morris in 1890

In the late 1860s, The Firm retailed another quite different group of wallpapers, including Indian, that were inspired by 18th-century precedents. These used only two colours which made them less expensive to produce. Although Morris did not favour the Victorian practice of using different patterned papers together, he bowed to commercial pressure and around 1868 designed *Diaper*, a two-toned, non-directional paper specifically for use on ceilings as a complement to The Firm's other wallpapers. Between 1872 and 1876 Morris executed a series of wallpapers that were different again, and which included "Larkspur", "Jasmine", "Acanthus", "Pimpernel", "Vine" and "Willow". These more closely patterned designs convey a strong sense of organic growth through the density of their scrolling foliage, and reveal a maturity of handling. The swirling organicism found in such patterns was stylized by a later generation of designers in the 1890s, and the more linear and sinuous forms that evolved became one of the most distinctive decorative features of Art Nouveau.

Morris executed the majority of his designs between 1876 and 1882. During these prolific years he designed 16 wallpapers, including "Acorn", all of which possessed a more formal pattern structure and appeared flatter than his earlier designs. This measured approach, in which the repeats were easily identified, may well have been inspired by his preoccupation, at that time, with weaving. He returned, however, to more naturalistic motifs for his later wallpapers, producing designs such as "Horn Poppy" (1885), which through the bold outlining of their patterns display a remarkable sense of rhythm.

During the 1890s, John Henry Dearle designed many wallpapers for Morris & Co. in The Firm's house style. His designs, such as "Compton" and "Golden Lily", with their swirling tendrils, recaptured the spirit of Morris's earlier work from the mid-1870s. Towards the turn of the century, however, Dearle developed a somewhat sweeter style, as evidenced by his "Orchard" wallpaper, which was more in tune with the design currents emanating from the Arts & Crafts Movement.

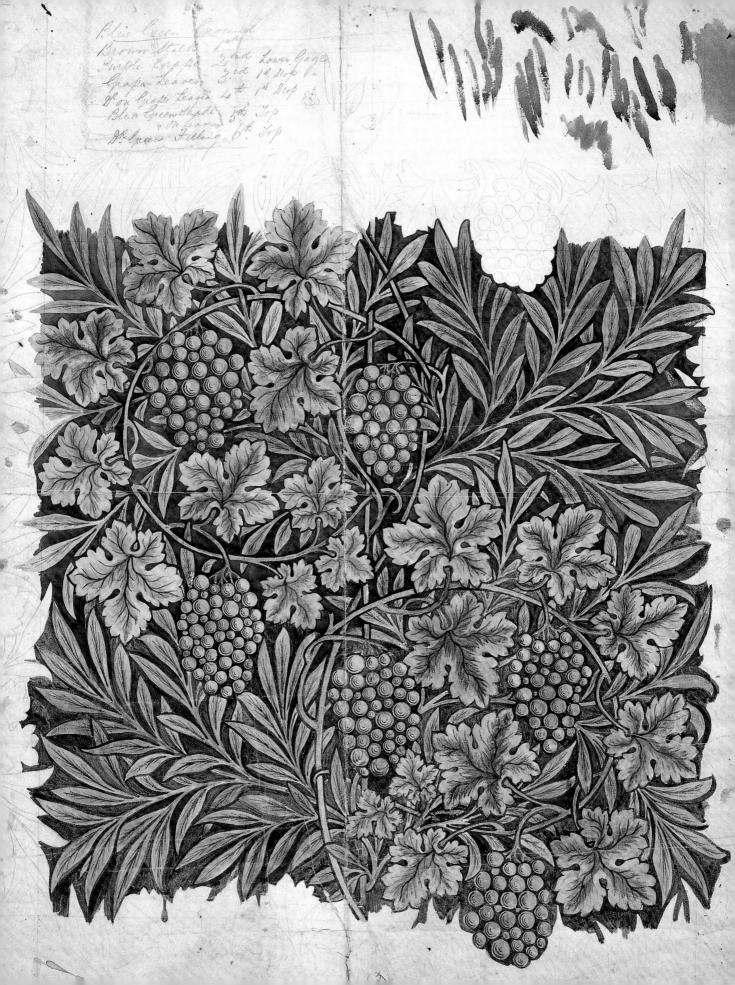

Blue Green Ground
Brown Stalk 1st
Purple Grape 2nd Lower Gage
Grape Leaves 3rd 1st Drop
D° on Grape Leaves 4th 1st Drop
Blue Green Shade 5th Top
" on Leaves
D° Green Filling 6th Top

Opposite page
Design for "Vine" wallpaper, *c.* 1873

Right
"Horn Poppy" wallpaper, registered 1885

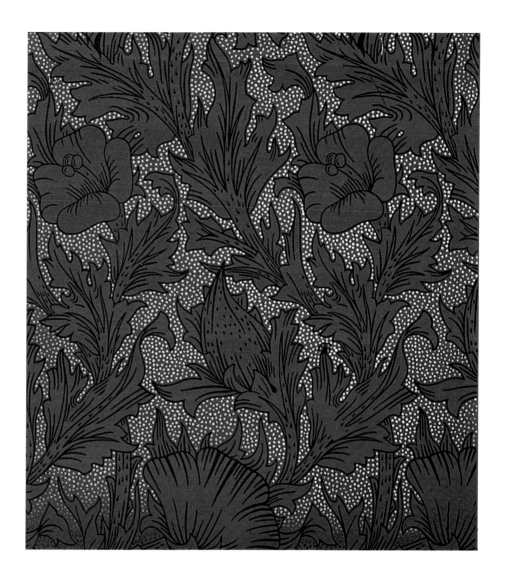

Page from Morris & Co. wallpaper catalogue

All of Morris & Co.'s wallpapers were originally printed by hand using woodblocks – a process that was painfully time-consuming. Many of The Firm's designs required up to 20 different blocks, while "St James" (1881) used a staggering 68. In 1925, Arthur Sanderson & Sons took over the manufacture of the wallpapers from Jeffrey & Co., and since the 1950s the company has continuously produced Morris & Co. wallpaper designs using both hand and mechanized production methods.

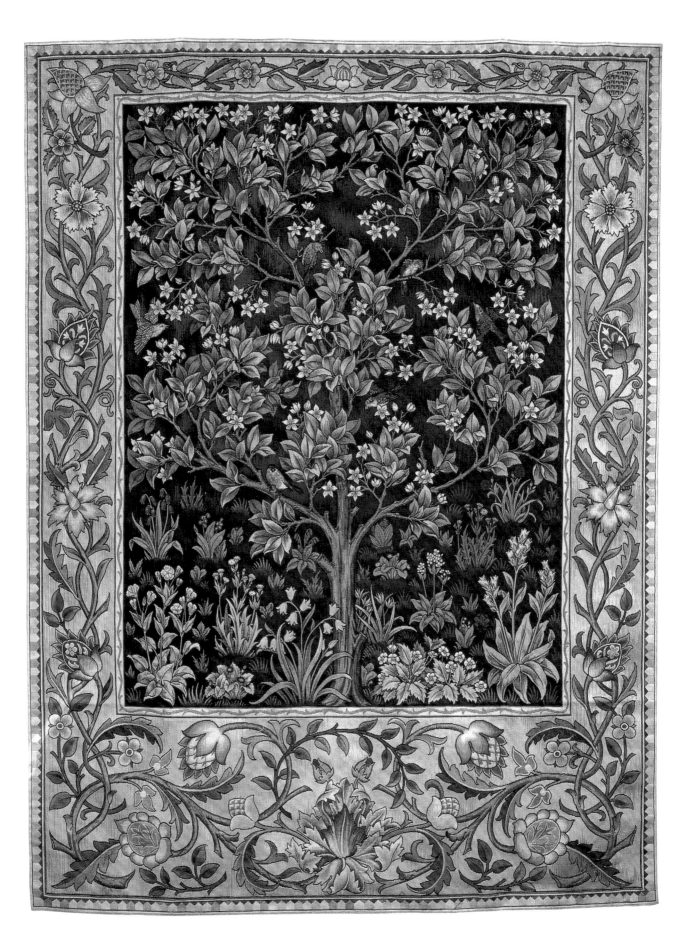

1857– ▸ Embroidery

"Daisy" hanging, 1860

Opposite
J. H. Dearle, Hanging, *c.* 1890

During the second half of the 19th century, the Anglo-Catholic Movement's campaign for a greater use of ritual within the Church of England led to an increased demand for ecclesiastical embroideries, such as altar cloths. Morris was introduced to this specialized craft while articled to the Gothic Revivalist architect George Edmund Street, who was involved in much church building and restoration. Street had already co-written an influential book, with Agnes Blencowe, entitled *Ecclesiastical Embroidery*, published in 1848. In this, he stated his opposition to the contemporary trend of cross-stitch work for church use and urged for more creative forms of needlework, such as embroidery. But whereas Street favoured using silks, which gave his embroideries a relative flatness, Morris initially preferred the use of wool yarns and backing which, though harder to work with, produced a greater three-dimensional effect. This in turn brought his embroideries closer in spirit to the medieval archetypes he so admired.

While Morris was living at 17 Red Lion Square, he had an embroidery frame made, based on an antique model. Using woollen yarns which he also had specially dyed for him, and with time-consuming diligence, Morris set about mastering the techniques of embroidery, including his preferred method of "laying and couching". He subsequently instructed his housekeeper, "Red Lion" Mary, on how to embroider his designs, and she became the first of many women during Morris's lifetime who painstakingly executed this type of work for him. The first known embroidery by Morris himself is a hanging dating from 1857, in which he employed a relatively crude method of working and aniline dyed wool. With its simple stylized tree and bird forms, this early design possesses a charming naïvety. Its "If I Can" motto makes reference to the 15th-century artist Jan Van Eyck's famous pun, "Als Ich Kan" ("As I Can" or "As Eyck Can").

Another early hanging, which was embroidered specifically for the Red House in 1860, used indigo-dyed woollen serge for its backing, while its laid and couched daisy motif was inspired by a 15th-century Froissart manuscript in the British Museum. The "Daisy" hanging, with its simple repeating motif and honest expression of the medium, embodies many of Morris's design principles. Indeed, the rustic vernacularism of this curtain must have seemed startlingly radical in its day. Between 1860 and 1865, Morris also designed a series of figurative panels for the Red House that depicted, among others, St Catherine, Penelope and Queen Guinevere.

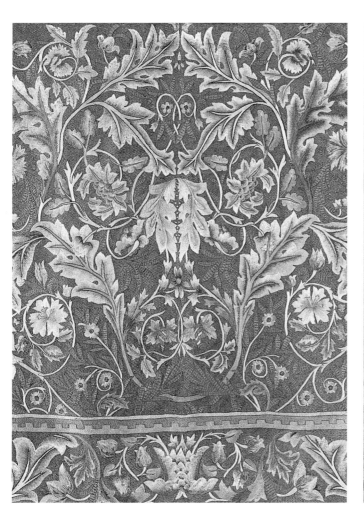

Above left
"Acanthus" sample hanging, c. 1880

Above right
"Qui bien aime, tard oublie" hanging,
early 1860s

Opposite page
"If I Can" hanging, 1856–57

When Morris, Marshall, Faulkner & Co.'s first prospectus was issued in April 1861, it stated that the co-operative would be producing and undertaking commissions for embroideries. In 1862 The Firm exhibited embroidered designs at the International Exhibition in South Kensington. Although not to everyone's taste, *The Clerical Journal* at least described them as "quaintly pleasing", even if it inaccurately referred to them as "reproductions".[32] After the exhibition, The Firm began to receive commissions for ecclesiastical embroideries from Gothic Revivalist architects, such as G. F. Bodley. These early and stylistically simple embroideries were co-designed by Morris and Webb and worked by the partners' friends and relatives, including Jane Morris, Georgiana Burne-Jones, and Lucy and Kate Faulkner.

When Morris eventually gained sole control of The Firm in 1875, the urgency of attaining financial viability became even more pressing. For Morris & Co. to survive, he realized that the range of designs it offered would have to become more commercially appealing. Around this time, Morris and Webb began designing flatter embroideries that were less medieval in style yet still required a traditional method of execution. During the 1870s, many site-specific commissions for domestic hangings and panels were obtained from secular clients, such as the industrialist Sir Isaac Lowthian Bell. In response to the increasing popularity of their embroideries, The Firm began retailing "kit" designs for cushion covers and fire-screen panels. With these, Morris's

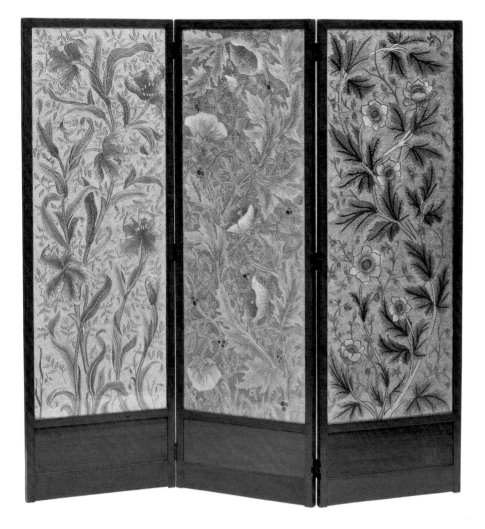

SCREENS FOR MOUNTING EMBROIDERIES.

intention was to grant the embroiderer greater creative freedom by leaving open the choice of stitch and colour of yarn. Morris was also closely associated with the Royal School of Needlework, which was established in 1872 for the promotion of ornamental needlework as an art form, and with Burne-Jones executed three designs for the institution.

Morris's sumptuous hangings of the late 1870s and 1880s, such as "Artichoke" and "Acanthus", were more complex and intricate in their patterning than his earlier designs and can be seen as a reflection of his growing interest in carpet-making. May Morris, who was a skilled needlewoman, having worked her father's designs from a very young age, took over Morris & Co.'s embroidery workshop in 1885. She and John Henry Dearle, who became The Firm's artistic director in 1896, subsequently designed all newMorris & Co. embroideries. Dearle's designs for portières, such as "Owl" and "Pigeon", though stylistically similar to Morris's designs of the 1880s, lack their vitality. After her father's death, May Morris wrote several articles on embroidery, showed her own designs at various Arts & Crafts exhibitions and lectured widely on the subject in Britain and America.

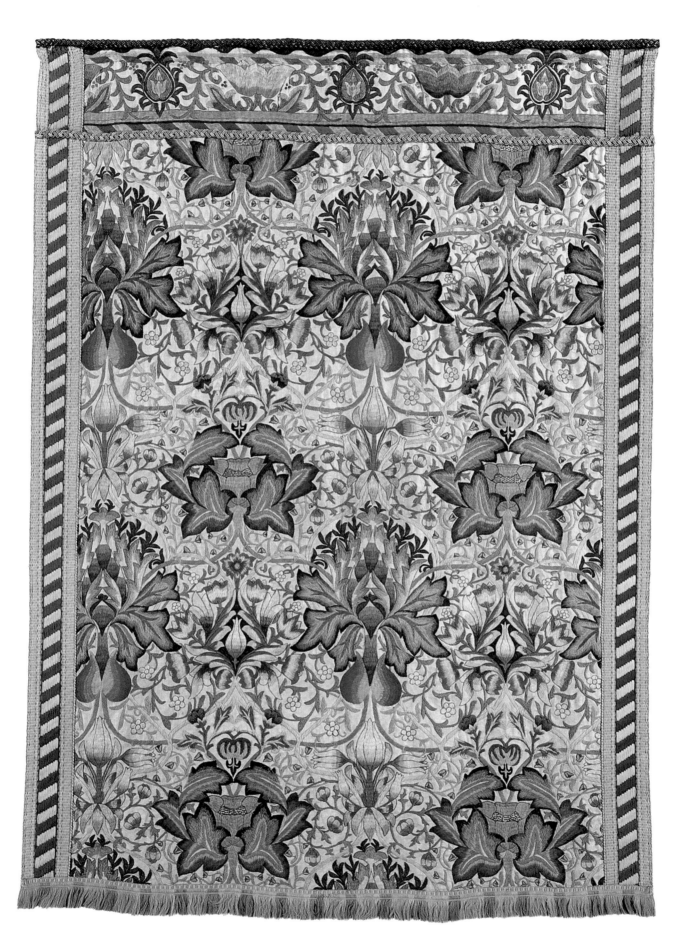

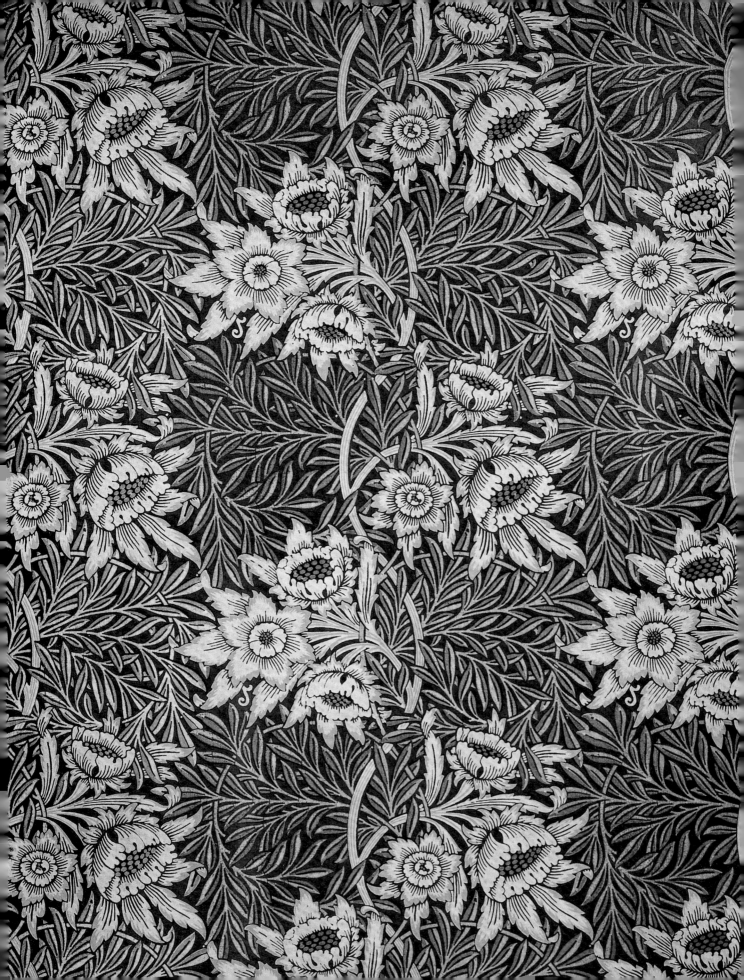

c. 1868– ▸ Printed Textiles

The first printed textiles retailed by Morris, Marshall, Faulkner & Co. from about 1868 were reissues of earlier floral designs from the 1830s, and were reproduced for The Firm by Thomas Clarkson of Bannister Hall, near Preston in Lancashire. Clarkson's soon afterwards printed Morris's first original design, "Jasmine Trellis" (*c.* 1868–1870), using synthetic dyes. This was followed by "Tulip & Willow", which Morris designed in 1873. When he saw the printed product, however, Morris was extremely disappointed with the quality of the colours. This was due to the aniline dyes, which he later stated had "terribly injured the art of dyeing".[33] Accordingly, Morris began researching ancient recipes for traditional natural dyes, consulting books such as Giovanni Ventura Roseto's *Plictho de l'arte de tentori* of 1540 and John Gerard's *The Herball, or, Generall Historie of Plants* of 1597.

When more space became available at Queen Square due to the Morris family's move to Turnham Green in 1872, Morris – with the help of John Smith (an assistant from the stained glass workshop) – began his own dyeing experiments using age-old formulas. Quickly realizing that there was still insufficient space for a commercial

Above
"Wandle" printed textile, registered 1884

Right
The textile printing workshop at Merton Abbey

Opposite page
"Tulip & Willow" printed textile, designed 1873

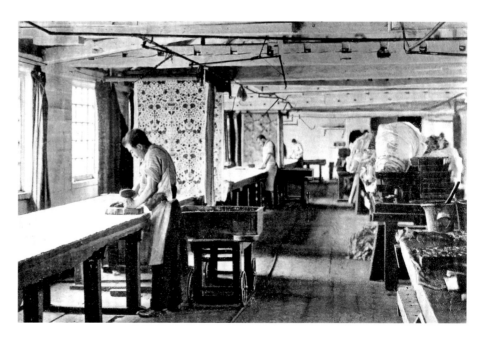

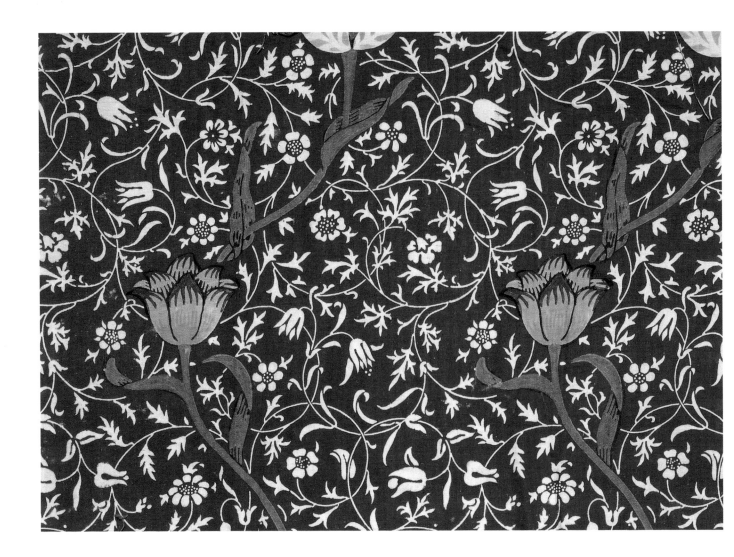

operation, Morris approached Thomas Wardle, the brother of his business manager, who had recently established his own silk dyeing and printing firm in Leek, Staffordshire. Wardle was sympathetic to Morris's desire to use natural dyes, although he employed modern aniline dyes himself. In the summer of 1875 Morris began large-scale dyeing experiments at Wardle's Hencroft Dye Works, the results of which led to alternating bouts of despair, anger and elation.

Morris's attempts at indigo discharge printing were beset with problems. This process, in which areas of colour were effectively bleached out, was applied to the printing of designs such as "Tulip & Willow", although it was not truly perfected until 1882. Nevertheless, in or around 1876 a further 14 designs by Morris, including "Snakeshead", "African Marigold" and "Honeysuckle" were successfully block-printed by Wardle using a restricted list of acceptable dyes and modern chemical dye-setting compounds. Despite this, Morris became increasingly concerned with quality control and Wardle's apparent failure to supervise his workers. By 1881, Wardle's standards of production had degenerated to such an extent that The Firm's clients were returning poorly printed textiles. Morris realized that the only way to achieve the high standards he desired would be to undertake the manufacturing himself, and so he began searching for suitable premises.

"Brother Rabbit" printed textile, designed 1880–81, registered 1882

The printing of textiles was moved that same year to Morris & Co.'s new works at Merton Abbey. But even given the closer supervision there, it took many frustrating months of trial runs before any successful results were achieved. After the move to Merton, all the necessary block-cutting for Morris & Co. printed textiles was undertaken by Alfred Barrett of Bethnal Green, and later by his son, James Barrett. First a tracing was made of the original design drawing, and then this transfer was rubbed onto the uncut pear wood block. Once the outlines of the design had been laboriously cut, it was "inked up" on a dye-pad before being carefully laid on the prepared cloth, which was supported on a blanketed table. When in position, the block would be struck with a mallet and cautiously lifted, then the process would be repeated. If the design called for more than one colour, different blocks with other colours would be printed once the preceding dye or dyes had dried. When the printing and fixing processes had been completed, the cloth was washed up to five times in the nearby River Wandle and laid out to dry in the meadows surrounding the Merton Abbey works. This exacting process ensured not only superlative quality but also higher costs, which had to be passed onto the client – even though The Firm's profit margins were a lot narrower than those of its competitors. A considerable number of Morris's own two-dimensional designs were used for both printed textiles and wallpapers.

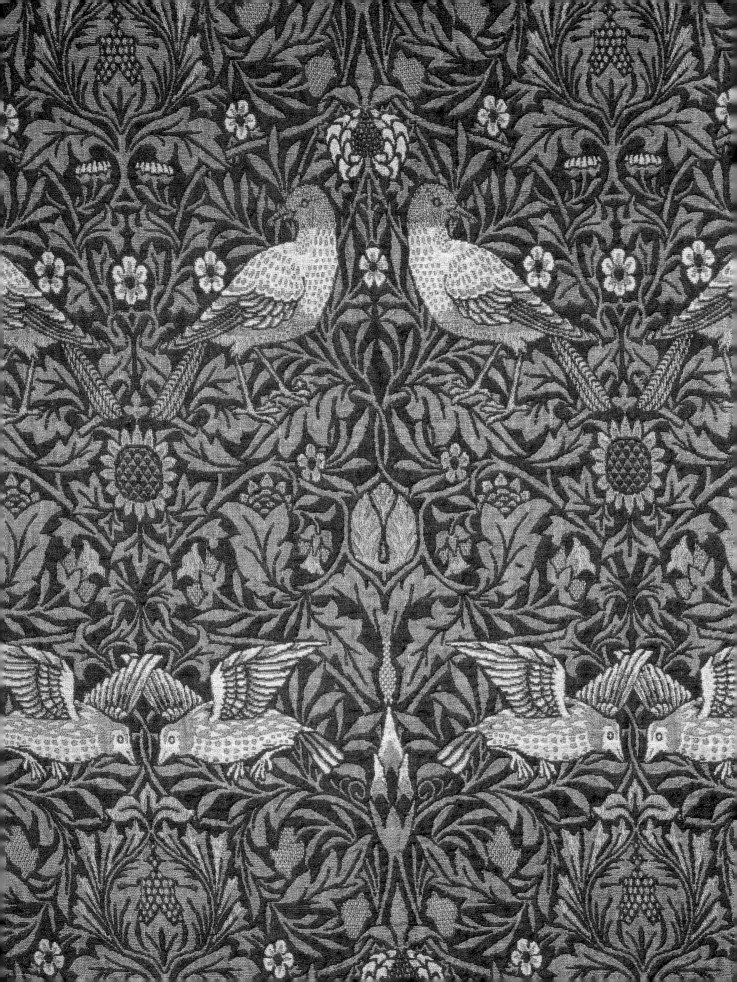

1877– ▸ Woven Textiles

Over many years, Morris studied antique textiles at the South Kensington Museum and amassed his own private collection of historical specimens, which served as technical and aesthetic points of reference for his own designs. His first woven textile design, which Morris & Co. confusingly referred to as "tapestry", was registered in 1876. Initially, the production of this and other early designs was subcontracted to established weavers, such as the Heckmondwike Manufacturing Company in Yorkshire. By early 1877, however, Morris decided to establish his own weaving workshop. To this end, Thomas Wardle helped Morris recruit Louis Bazin, a professional silk weaver from Lyons. In September 1877, a suitable workspace was found in Great Ormond Yard and Bazin set to work. It took a few frustrating weeks, nevertheless, to perfect the production of The Firm's woollen brocades. These textiles, such as "Bird" (1877–78), were woven on a Jacquard loom that Bazin had brought over with him from France. Although this was a hand-loom that used a mechanical system of

Opposite page
"Bird" woven textile, designed 1878

Right
Hand-activated jacquard looms in the fabric-weaving sheds at Merton Abbey

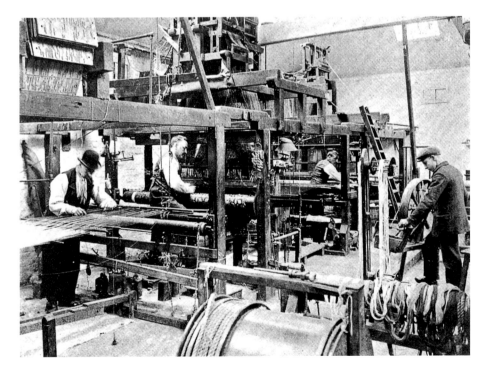

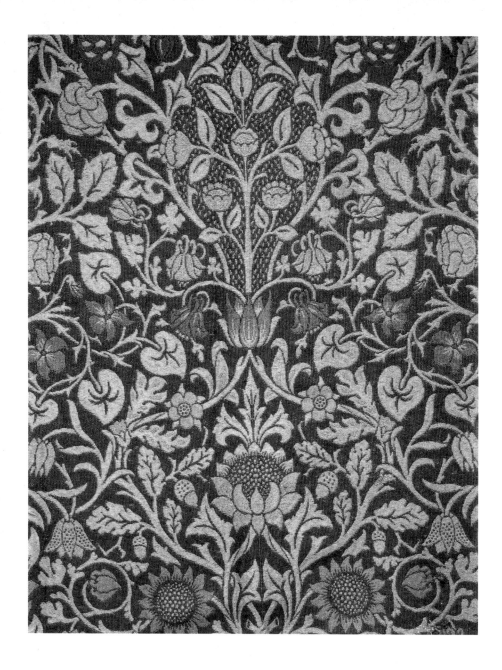

punched cards to create the required pattern, Morris accepted this form of mechaniza-
tion as it provided significantly better quality than traditional production methods. The
Firm also produced many patterned textiles on Jacquard power-looms, and in the late
1870s and 1880s Morris & Co. manufactured exquisite silk brocades and damasks as
well as fine broché dress silks. In 1881, the weaving workshop was moved from London
to Merton Abbey, and from the late 1880s J. H. Dearle designed the majority of woven
textiles retailed by Morris & Co.

Above
**"Violet & Columbine" woven textile,
registered 1883**

Opposite page
**J. H. Dearle, "Elmcote" woven textile,
designed *c.* 1900**

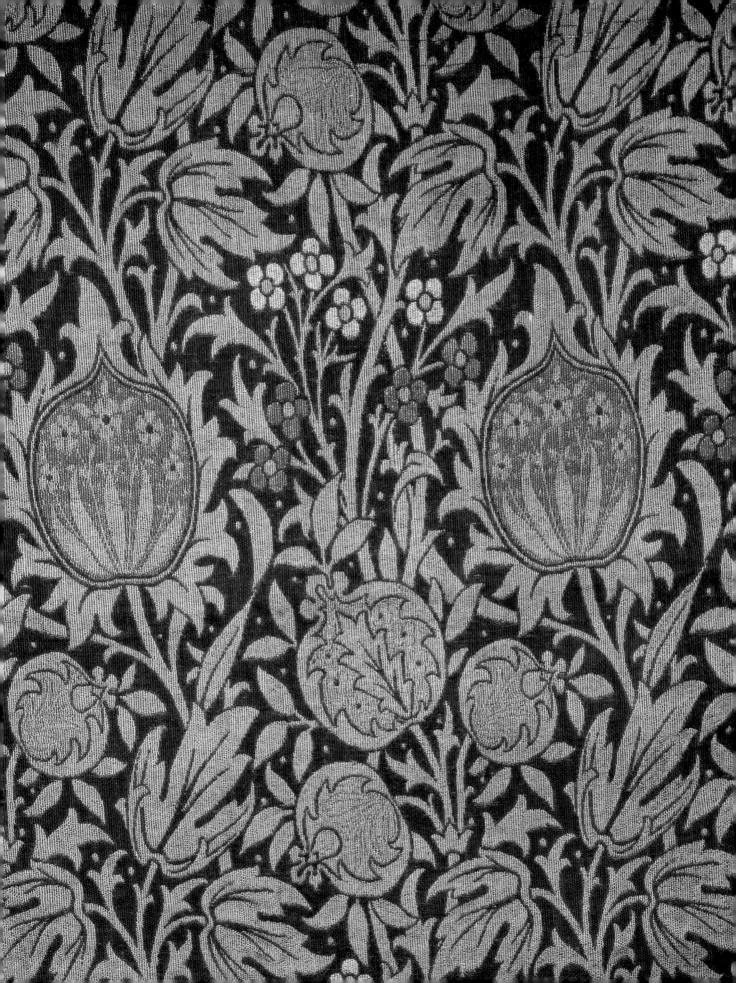

1877– ▸ Tapestry

It is not surprising that, as a consummate storyteller, Morris regarded tapestry as the highest form of textile design. Like stained glass, woven tapestries could retell tales of long ago with an immediacy and accessibility that is difficult to comprehend in our own era. In 1877, Thomas Wardle attempted to persuade Morris to set up a "non-artistic manufactory"[34] for the commercial production of tapestries, but Morris rejected the idea: the mechanized method of production available at that time was, he felt, creatively too limiting. Instead, Morris turned his attention to traditional methods of high-warp tapestry weaving, and in 1878 began fervently experimenting with a loom that he set up in his bedroom. Once he had mastered the techniques of tapestry weaving, Morris founded a workshop at Queen Square that was headed by J. H. Dearle.

Morris believed that to create successful tapestry designs it was essential to be a good colourist and draughtsman, to have a feeling for art in general, and to possess a sound understanding of the techniques and technologies involved – attributes he certainly possessed. Many of the Morris & Co. tapestries were collaboratively designed by Morris, Edward Burne-Jones (who usually executed the figures), Philip Webb (who drew animals and birds) and J. H. Dearle. The design process would very often begin with Burne-Jones producing a preliminary design for the figures, which was then translated into a coloured drawing by Morris or Dearle. Following this, a cartoon of the drawing would be made by photographic means. Morris or Dearle would then add the decorative borders and fill in the background and foreground by tracing over the cartoon with their own designs of flowers and trees. This first tracing and the photographic cartoon were subsequently taken by the weaver and retraced together. The resulting complete design on this second tracing was then transferred onto the warp by rubbing with a small piece of ivory.

Once The Firm had moved its weaving workshops into sheds at Merton Abbey in 1881, it was able to undertake large-scale production of tapestries. At Merton, the weaving of tapestries on vertical looms was, for the most part, done by boys of 13 or 14 years old, who were provided with board and lodgings as well as a weekly wage. Although The Firm retailed smaller-scale designs for cushion covers and furniture upholstery panels, the majority of its tapestry designs such as "The Woodpecker" (1885), were conceived as decorative hangings. These tapestries were either secular or sacred in theme, depending on whether they were destined for a private home or a church. Particular designs were repeated over and over again. Ten versions of the Adoration

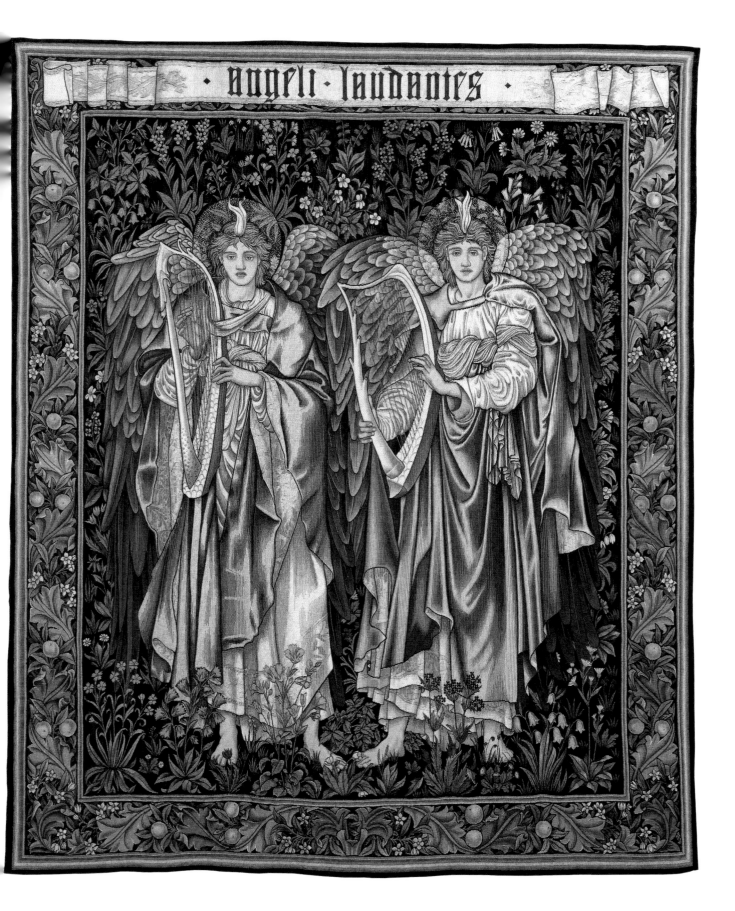

81

Edward Burne-Jones, "The Arming and Departure of the Knights of the Round Table on the Quest for the Holy Grail" tapestry by Morris & Co., 1890

William Morris, Philip Webb & J. H. Dearle, "The Forest" tapestry, 1887

tapestry, for example, were woven between 1890 and 1907, although each differed somewhat, with its own border design. The largest tapestry project undertaken by The Firm was the Holy Grail series of 1890, which comprised five narrative panels with life-sized figures and six smaller foliate panels. The subject-matter of this woven cycle, which was commissioned by William Knox D'Arcy for Stanmore Hall, was described by Morris as "the most beautiful and complete episode of the legends".[35]

Right
"The Woodpecker" tapestry, *c.* 1885

Far right
**Edward Burne-Jones & J. H. Dearle,
"Pomona" tapestry,** *c.* 1900

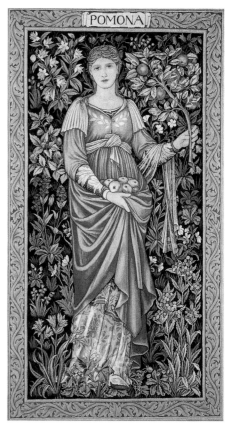

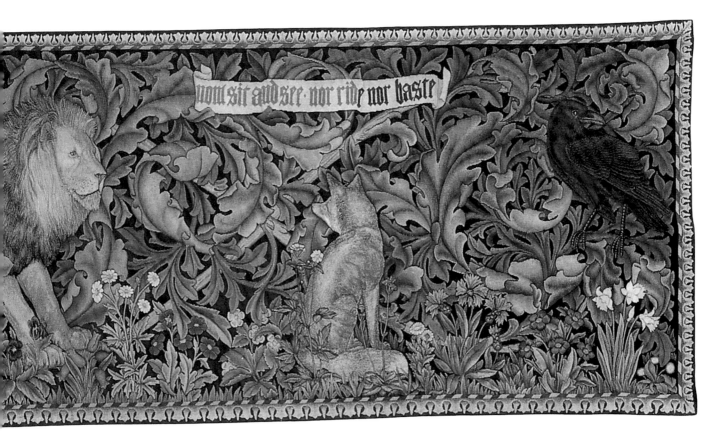

In March 1875 Morris became sole proprietor of The Firm, and almost at once began diversifying its product range in an effort to boost sales and achieve financial stability. Within three months, he registered a design for a linoleum floor-covering by the name of "Corticine floor cloth", and in December of the same year he registered two designs for machine-woven Wilton carpets. By the 1880s, The Firm was retailing a large range of machine-made Axminster, Wilton and Kidderminster carpets that Morris had begun designing in the mid-1870s. The production of these commercial carpets was subcontracted to the Wilton Royal Carpet Factory Co. and the Heckmondwike Manufacturing Company in Yorkshire. Stylistically, the machine-made designs differed significantly from The Firm's Hammersmith range of hand-knotted carpets and rugs – the Kidderminster carpeting was actually technically and aesthetically closer to Morris & Co. woven textiles, while the Axminster and Wilton carpets had tighter and more

"Daisy" Kidderminster carpet, *c.* 1875
(manufactured by Heckmondwike)

Right
Girls working on a carpet loom
at Merton Abbey, *Art Journal*, 1883

Opposite page
William Morris & J. H. Dearle,
"Bullerswood" carpet, 1889

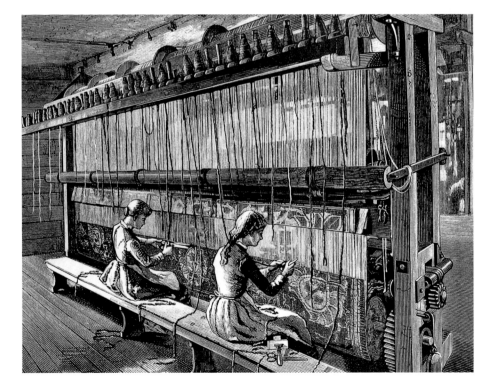

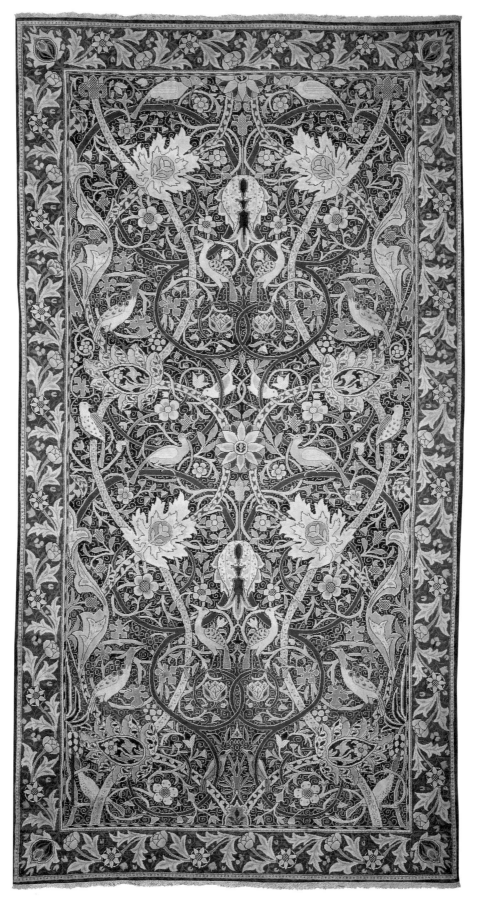

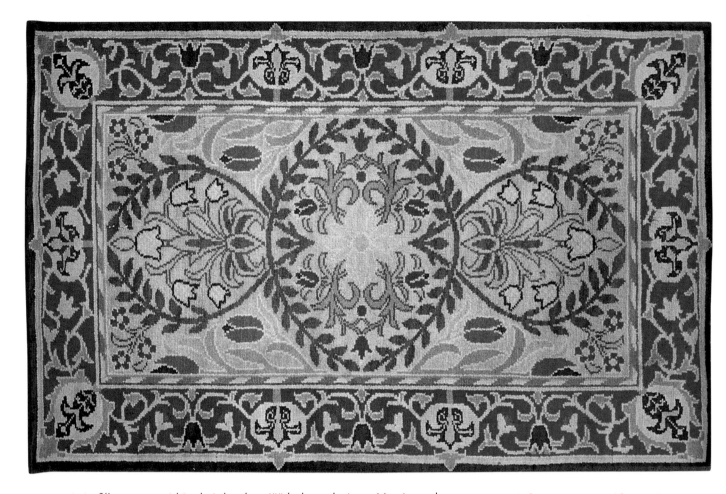

geometric in-fill patterns within their borders. With these designs, Morris made a rare concession to industrialization. He did this largely for commercial reasons, no doubt believing that if The Firm did not produce and retail good quality, affordable and aesthetically pleasing machine-made carpets, one of its competitors eventually would.

Morris & Co., Hammersmith rug, 1890

 Despite his acquiescence to industrial production, Morris most wanted "to make England independent of the East for the supply of handmade carpets which may claim to be considered works of art".[36] While living at Queen Square, he therefore began investigating first hand the techniques of carpet weaving, and executed several trial samples. As an acknowledged authority on Eastern carpets whose expert opinion was frequently sought by the keepers of the South Kensington Museum for purposes of attribution, it is not surprising that Morris's own designs were inspired by those of the Orient. It was not until his move to Kelmscott House in 1879, however, that Morris was able to set up a carpet workshop and begin realizing his objectives. The carpet "factory" was situated in the stables and coach house of his home and employed a mainly female workforce. Although the Hammersmith hand-knotted rugs and carpets produced there did not match their Oriental antecedents in terms of technical quality, they did possess a charming lack of sophistication. In 1881 Morris & Co.'s carpet-making activities were transferred to Merton Abbey, where much larger designs, such as *Clouds* and *Bullerswood*, were produced. These enormous, specially commissioned carpets were freer in style and more English in their inspiration than the earlier Hammersmith work. With their homely appeal, Morris & Co. hand-knotted carpets had a marked influence on the later Arts & Crafts revival of carpet making.

Below
William Morris, Edward Burne-Jones & Charles Fairfax Murray, *The Aeneids of Virgil*, 1874–75
Illustrated page

Page 88
William Morris, Edward Burne-Jones, Charles Fairfax Murray & George Wardle, *A Book of Verse*, 1870
Front page

Page 89
William Morris, Edward Burne-Jones & Charles Fairfax Murray, *The Odes of Horace*, 1874
Illustrated page

Morris began to develop expert knowledge of and a connoisseur's eye for French and English medieval illuminated manuscripts as a result of his studies at the Bodleian Library in Oxford and the British Museum in London. He was dedicated to the idea of rekindling this ancient art form from as early as 1857, and while living at Red Lion Square he made a number of abortive attempts at manuscript illumination and calligraphy. These earlier trials led Morris, from around 1869, to begin teaching himself the skills required. He had in his possession four 16th-century Italian writing manuals, which must have been invaluable to him in his painstaking attempts to master both Roman and Italic scripts. Morris also attempted to perfect the difficult technique of gilding letters, which involved laying gold leaf onto a gesso ground and then burnishing it. Over the next five years, he found time in his busy schedule to execute over 1,500 illuminated manuscript pages on both paper and vellum. In this large body of work, which included two completed books, a score of unfinished book projects and a great number of trial pages and fragments, Morris did not so much replicate medieval manuscript techniques as revive and revitalize the arts of illumination and calligraphy in a contemporary manner. His approach developed from a rather sweet and tentative style, as illustrated by *A Book of Verse* (1870), to the mature and confident work in his two last major calligraphic projects, *The Odes of Horace* and *The Aeneids of Virgil* (both 1874) with their exquisite jewel-like borders and ciphers. Morris's illuminated manuscripts must be seen on one hand as highly private expressions of his personal creativity and on the other as an important steps towards his founding of the Kelmscott Press.

OTUMEX
METELLO
CONSULE
CIVICUM
BELLIQUE
CAUSAS ET VITIA
ET MODOS

 ludumque fortunae gravesque
 Principum amicitias et arma
Nondum expiatis uncta cruoribus,
periculosae plenum opus aleae,
 tractas, et incedis per ignes
 suppositos cineri doloso
Paullum sevaerae Musa tragediae
desit theatris: mox ubi publicas
res ordinaris, grande munus
 Cecropio repetes cothurno
Insigne maestis praesidium reis

THIS IS THE PICTURE OF THE OLD
HOUSE BY THE THAMES TO WHICH
THE PEOPLE OF THIS STORY WENT
HEREAFTER FOLLOWS THE BOOK IT-
SELF WHICH IS CALLED NEWS FROM
NOWHERE OR AN EPOCH OF REST &
IS WRITTEN BY WILLIAM MORRIS.

The Press Room of the Kelmscott Press

Opposite page
News from Nowhere, 1892

Morris had a profound interest in fine books, having been an avid collector for many decades and having himself produced two exquisite illuminated manuscript books during the 1870s. He also had practical publishing experience as a result of his editorship of both *The Oxford & Cambridge Magazine* and *Commonweal*. After attending a lecture in 1888 given by his friend Emery Walker, who had a process-engraving business, Morris was determined to design a new typeface and to have it cast. This interest in typography also led him to select the typeface and oversee the lay-out for his book *The House of the Wolfings*. Although somewhat disappointed with the resulting volume, which was published by the Chiswick Press in 1888, he was enraptured by the typography and binding of *The Roots of the Mountains* – his second book, printed by the Chiswick Press in 1889. During the 1890s, Morris's time was relatively free from political activities and the day-to-day running of Morris & Co., and this enabled him to pursue his own artistic and creative interests. It is not at all surprising that he eventually immersed himself fully in fine art publishing, for he believed that a beautiful book came second only to a beautiful house. As with his other craft interests, Morris undertook preliminary research into the techniques and materials, such as handmade papers

The first colophone for
the Kelmscott Press, 1890

and inks, required for this venture. He also consulted Emery Walker, T. J. Cobden-Sanderson, who ran Doves Bindery at 15 Upper Mall, and the art publisher C. T. Jacobi, who founded the Chiswick Press.

In January 1891 Morris rented suitable premises at 16 Upper Mall – a small cottage close to his Hammersmith home – and established the Kelmscott Press. Shortly afterwards, the newly formed publishing house printed the first edition of Morris's *The Story of the Glittering Plain* using a single Albion press. The initial run of 200 books was intended for book lovers and collectors and sold out immediately. From the outset, the Kelmscott Press was a critical and financial success. As a result of this, they had to move to larger premises at 14 Upper Mall and purchase a second Albion press to speed up production. Morris's employees at the press were better paid than some, but unlike their colleagues at Merton Abbey, had working conditions that differed little from other printing works.

The excellence of the work produced by the Kelmscott Press ranks very highly in the history of printing. Over its eight years of operation, it produced 53 titles on either fine handmade papers or, in special cases, vellum, and printed a total of 18,234 volumes. With their splendid woodcut illustrations designed by Edward Burne-Jones, Walter Crane and C. M. Gere, and their swirling medieval-style borders and ciphers by Morris, these editions were designed to be beautiful. They were also intended to be easily read and this concern for clearly decipherable typography prompted Morris to design three new typefaces: Golden (based on a 15th-century Venetian Roman type), Troy (a gothic type) and Chaucer (a reduced version of Troy). The designs for the types were reduced, photographically transferred and cut into steel punches so as to be able to be cast into metal founts, that were sufficiently strong to bear the pressure produced by the Albion hand-press. The nature of the texts that were printed ranged considerably – 23 were written by Morris, 22 were of medieval origin, 13 were of contemporary poetry, while the remainder included the reprint of a chapter from John Ruskin's *The Stones of Venice* entitled *On the Nature of Gothic*.

The Story of the Glittering Plain,
published 1891

Above left
The Works of Geoffrey Chaucer, published 1896
Illustrated page

Above right
The Works of Geoffrey Chaucer, published 1896
Stamped pigskin binding designed by
William Morris

The most important project undertaken by the Kelmscott Press was the publication of *The Works of Geoffrey Chaucer* (1891–96), which took five years to complete. Known as the *Kelmscott Chaucer*, this magnificent volume of 556 pages serves as a vast lexicon of decorative motifs, with 86 illustrations by Burne-Jones and 664 different designs by Morris for initial monograms, borders, title-pages and so forth. Morris commented: "It was only natural that I, a decorator by profession, should attempt to ornament my books suitably; about this matter I will only say that I have always tried to keep in mind the necessity for making my decorations a part of the page type."[37] The Kelmscott Chaucer was heavily over-subscribed, even though it was extremely expensive: the version printed on handmade paper, of which 425 copies were produced, cost £20, while the version printed on finest vellum, of which just 13 copies were printed, cost £120. Issued only a few months before his death, the *Kelmscott Chaucer* can be seen as a glorious culmination of Morris's highly illustrious career, and as a fitting epitaph to one of the most talented, driven and enlightened design entrepreneurs of the 19th century.

Life and Work

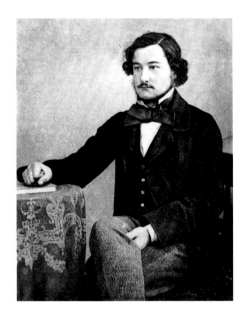

William Morris, aged 23

1834 William Morris is born on 24 March in Walthamstow.

1843 Attends Misses Arundel's academy for young gentlemen.

1845 The Devonshire Great Consolidated Copper Mining Company (Devon Great Consols) is officially registered.

1847 William Morris Snr. dies.

1848 Attends Marlborough College. Pre-Raphaelite Brotherhood founded by William Holman Hunt, John Everett Millais and Dante Gabriel Rossetti.

1852 Placed under the tutelage of Revd Frederick Guy. Sits matriculation exam for Exeter College, Oxford. Meets Edward Burne-Jones.

1853 Attends Exeter College, Oxford.

1855 Makes second journey to France, with Edward Burne-Jones and William Fulford. Abandons theology for "a life of art".

1856 Enters the architectural office of George Edmund Street. First number of *The Oxford and Cambridge Magazine* is published. Introduced to Dante Gabriel Rossetti by Edward Burne-Jones. Abandons architecture for painting

on the recommendation of Dante Gabriel Rossetti. Shares apartment with Edward Burne-Jones at 17 Red Lion Square, London.

1857 Paints murals at the Oxford Union Library with, among others, Dante Gabriel Rossetti and Edward Burne-Jones. Meets and falls in love with Jane Burden.

1858 Becomes officially engaged to Jane Burden in the spring. Publishes, at his own expense, *The Defence of Guenevere and Other Poems*.

1859 Marries Jane Burden on 26 April in Oxford. The Red House designed by Philip Webb.

1860 The Red House is completed and the Morrises move in.

1861 Jane Alice Morris (Jenny) is born on 18 January. Founds Morris, Marshall, Faulkner & Co. with six other partners.

1862 Morris, Marshall, Faulkner & Co. exhibit in the Medieval Court at the International Exhibition, South Kensington. Mary Morris (May) is born on 25 March.

1864 Designs first wallpapers.

1865 Morris family move to 26 Queen Square, London. George Warington

Taylor appointed business manager of Morris, Marshall, Faulkner & Co. Begins composing *The Earthly Paradise*.

1866 The Firm receives its first major public commissions for the decoration of the Armoury and Tapestry Room at St James's Palace and the Green Dining Room at the South Kensington Museum.

1867 Philip Webb appointed furniture manager of Morris, Marshall, Faulkner & Co. *The Death of Jason* is published.

1868 First volume of *The Earthly Paradise* is published.

1869 William and Jane Morris stay at Bad Ems for six weeks. Meets the Icelandic translator Eiríkr Magnússon. Translation of *The Story of Grettir the Strong* is published.

1870 Executes an illuminated manuscript book entitled *A Book of Verse*. Translation of *The Story of the Volsungs and Niblungs* is published.

1871 Signs joint lease on Kelmscott Manor with Dante Gabriel Rossetti. Travels to Iceland.

1872 Morris family moves to Horrington

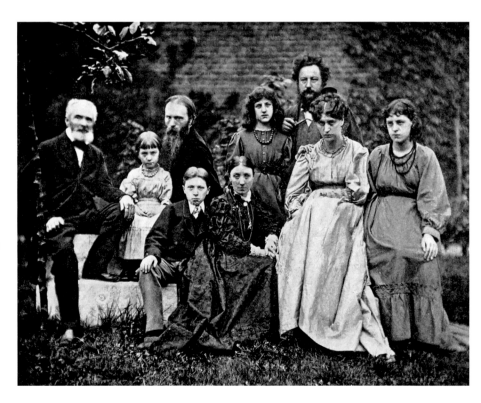

The Morris & Burne-Jones families, 1874

House, Turnham Green.
Begins dyeing experiments.

1873 Travels to Iceland.
"Love is Enough" is published.

1874 Dante Gabriel Rossetti relinquishes his share of the lease on Kelmscott Manor. Morris takes sole control of The Firm and renames it Morris & Co.

1875 Undertakes large-scale dyeing experiments at Hencroft Dye Works, Leek.

1876 Translation of *The Aeneids of Virgil* is published.

1877 Establishes the Society for the Protection of Ancient Buildings (nicknamed "Anti-Scrape").
Delivers "The Lesser Arts" lecture to the Trades Guild in Oxford.
Opens a Morris & Co. showroom in Oxford Street to retail The Firm's designs.
Establishes workshop to produce woven textiles.

1878 Morris family moves to The Retreat, Hammersmith, and renames property Kelmscott House.

1879 Becomes treasurer of the National Liberal League.
Sets up carpet factory in the stables and coach-house of Kelmscott House.

1881 Signs lease for works at Merton Abbey.

1882 Dante Gabriel Rossetti dies.
Reads Karl Marx's *Das Kapital*.

1883 Joins the Democratic Federation.
Morris & Co. exhibits at the Foreign Fair at Franklin Hall in Boston.
Delivers "Art under Plutocracy" lecture at University College, Oxford.

1884 Delivers "Useful Work and Useless Toil" lecture at the Hampstead Liberal Club.
Establishes Hammersmith branch of the Democratic Federation.
Resigns from the Democratic Federation and forms the Socialist League.

1885 Arrested for allegedly hitting a policeman.
Chants for Socialists published by the Socialist League.

1886 Serialization of *A Dream of John Ball* commences in *Commonweal*.

1888 *The House of the Wolfings* is published.
The first Arts & Crafts Society Exhibition is held.

1889 Serialization of *News from Nowhere* commences in *Commonweal*.
The Roots of the Mountains published.

Edward Burne-Jones & William Morris, 1880s

1890 Hammersmith branch of the Socialist League leaves the organization and is renamed the Hammersmith Socialist League.
Robert and Frank Smith become partners in Morris & Co.
The Firm acquires furniture factory in Pimlico.

1891 Establishes the Kelmscott Press at 16 Upper Mall, Hammersmith.
Kelmscott Press publishes first book, *The Story of the Glittering Plain*.

1893 Drafts *The Manifesto of The English Socialists* with H. M. Hyndman and George Bernard Shaw.

1896 Travels to Norway.
Kelmscott Press publishes *The Works of Geoffrey Chaucer*.
John Henry Dearle becomes artistic director of Morris & Co.

William Morris dies at Kelmscott House on 3 October.

1898 Edward Burne-Jones dies.

1914 Jane Morris dies.

1934 Memorial Hall designed by Ernest Gimson is opened at Kelmscott.

1935 Jenny Morris dies.

1938 May Morris dies.

Notes

1 William Morris: *How I became a Socialist*, in: *Justice*, 1894, in: Fiona MacCarthy: *William Morris, A Life for our Time*, p. 263.
2 William Gaunt: *The Pre-Raphaelite Dream*, p. 165.
3 MacCarthy, p. 3.
4 Charles Harvey & Jon Press: *William Morris, Design and Enterprise in Victorian Britain*, p. 10.
5 David Rodgers: *William Morris at Home*, p. 23.
6 MacCarthy, p. 34.
7 Mackail, vol. 1, p. 29.
8 Mackail, vol. 1, p. 35.
9 Edward Burne-Jones, letter to Cormell Price, May 1853, in: MacCarthy, p. 67.
10 Ibid., p. 74.
11 Edward Burne-Jones, in: MacCarthy, p. 95.
12 Thompson, p. 44.
13 Ibid., p. 139.
14 Aymer Vallance: *The Life and Works of William Morris*, p. 438.
15 Ernest Rhys, introduction to the 1911 edition of *The Life and Death of Jason* published by J. M. Dent, p. ix.
16 Mackail, vol. 1, p. 318.
17 MacCarthy, p. 210.
18 William Morris, "Beauty of Life" lecture, in: Rodgers, p. 109.
19 Morton, p. 63.
20 Mackail, vol. 2, p. 147.
21 David Benedictus: "The Man who Banned Mumbo Jumbo", *Evening Standard*, 27 April 1979.
22 Georgiana Burne-Jones: *Memorials of Edward Burne-Jones*, vol. 1, p. 208.
23 Linda Parry: *William Morris Textiles*, p. 13.
24 Vallance, p. 44.
25 MacCarthy, p. 178.
26 Linda Parry (ed.): *William Morris*, ex. cat., p. 107.
27 Ibid., p. 158.
28 Harvey & Press, p. 43.
29 Annette Carruthers & Mary Greensted: *Good Citizen's Furniture, The Arts & Crafts Collection at Cheltenham*, p. 9.
30 E. P. Thompson: *The Work of William Morris*, pp. 83, 85.
31 Carruthers & Greensted, p. 9.
32 *The Clerical Journal*, vol. X, 8 May 1862, p. 241.
33 William Morris, "Of Dyeing as an Art", lecture, 1889.
34 Mackail, vol. 1, p. 363.
35 Parry (ed.), ex. cat., p. 294.
36 MacCarthy, p. 403.
37 Fridolf Johnson: *William Morris, Ornamentation and Illustrations from the Kelmscott Chaucer*, Introduction, p. xi.

Credits